The Romantic Legacy

෩

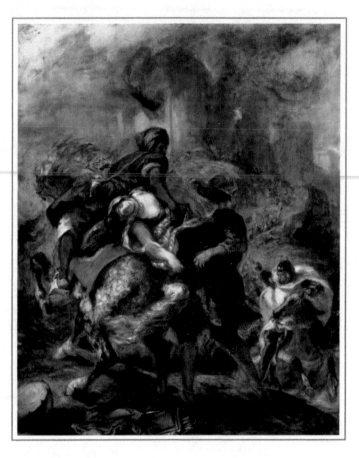

Eugène Delacroix, *The Abduction of Rebecca*, 1846.

The Romantic Legacy

CHARLES LARMORE

Columbia

University

Press

NEW YORK

Columbia University Press

New York Chichester, West Sussex

Copyright © 1996 Charles Larmore

Frontispiece: Eugène Delacroix,
The Abduction of Rebecca, 1846. Oil on canvas,
39⅛ in. × 32¼ in. Courtesy The Metropolitan
Museum of Art, Catharine Lorillard Wolfe
Collection, Wolfe Fund, 1903 (0.30).

Library of Congress
Cataloging-in-Publication Data
Larmore, Charles E.
The romantic legacy / Charles Larmore.
p. cm.
Includes bibliographical references and index.
ISBN 978-0-231-10134-9 (alk. paper)
1. Romanticism. I. Title.
PN56.R7L37 1996
809'.9145—dc20 95-25554
CIP

Designed by Teresa Bonner
Printed in the United States of America

c 10 9 8 7
6 5 4
3 2

For Julia

University Seminars
ℬ *Leonard Hastings Schoff Memorial Lectures*

The University Seminars at Columbia University
sponsor an annual series of lectures, with the support
of the Leonard Hastings Schoff and Suzanne Levick Schoff
Memorial Fund. A member of the Columbia faculty is
invited to deliver before a general audience three lectures
on a topic of his or her choosing. Columbia University
Press publishes the lectures.

CONTENTS

ACKNOWLEDGMENTS

This book comprises the second annual series of University Seminars/Leonard Hastings Schoff Memorial Lectures, which I gave at Columbia University in October 1994. I am very grateful to the Leonard Hastings Schoff and Suzanne Levick Schoff Memorial Trust, whose generosity made these lectures possible.

I would also like to thank Mr. Aaron Warner, director of the University Seminars at Columbia, for his material support and assistance as I prepared and gave the lectures.

Fred Beiser, Andreas Huyssen, Mark Lilla, Glenn Most, Harro Müller, and my wife, Amey, all read the manuscript in its entire-

ty and offered many valuable suggestions and criticisms, which I have sought to make the most of.

Finally, I would like to thank John Moore, Ann Miller, Jan McInroy, and Anne McCoy of Columbia University Press for their advice and help in the publication of this book.

The Schoff Memorial Lectures are intended for a general audience, and I have kept this goal in mind, both in the version of the lectures that I originally delivered and in their present published form. References to the secondary literature have been kept to an absolute minimum. Also, though I have not knowingly simplified any of the ideas I explore, I have tried to lay them out vividly rather than go through all the ins and outs of argument as a philosophical treatise might require. My aim has been to show that we all should take more seriously than we do certain key elements in our Romantic legacy. My hope is that philosophers, too, will find the attempt provocative.

INTRODUCTION

A little over seventy years ago, Arthur O. Lovejoy, the philoso-
pher and founder of the discipline of the history of ideas, wrote
an important essay that would seem to imply that this book,
devoted as it is to something called "Romanticism," is engaged
in an impossible project.[1] Lovejoy's thesis was that no signifi-
cant view of man and the world, no distinctive form of thought
or aesthetic, unites all the many things commonly assigned to
the "Romantic Movement." The profusion of cultural phe-
nomena produced in the West during the period 1780 to 1848,

[1] Arthur O. Lovejoy, "On the Discrimination of Romanticisms" [1924], in *Essays in the
History of Ideas* (Baltimore: Johns Hopkins University Press, 1948), pp. 228–53.

the very arbitrariness of these cutoff dates, the profound disparities among the various national cultures, the far from negligible ideological and aesthetic conflicts that cut across this period, the substantial differences among the various arts and between art itself and discursive (that is, philosophical and political-social) forms of thought—all these factors, Lovejoy insisted, must condemn to failure any attempt to distill the essence of Romanticism.

Lovejoy's argument has considerable force. Indeed it is, on its own terms, unanswerable. By that I mean that the proper response cannot lie in attempting what he said was impossible—finding a formula that does cover everything commonly subsumed under the term *Romanticism*. Such a reply was made by René Wellek, one of the founders of the discipline of comparative literature, whose definition proposed "imagination for the view of poetry, nature for the view of the world, symbol and myth for poetic style," in general "the reconciliation of subject and object."[2] The defect of the formula is obvious. The key terms are hopelessly vague, as they must be to take in everything typically classified as Romantic, and as a result they apply to much else as well.

Yet while I share Lovejoy's view as to the impossibility of an all-inclusive definition, I cannot agree that we should therefore

[2] René Wellek, "The Concept of Romanticism in Literary History" [1949] and "Romanticism Re-examined," in *Concepts of Criticism* (New Haven: Yale University Press, 1963), pp. 161 and 218, respectively.

stop using the term.[3] Too much in our cultural inheritance and understanding is bound up with determining what we will call "Romantic" and what our attitude toward it will be. Every culture has its key words—*Romanticism* is one of ours—which, however ill-defined or essentially contestable they may be, make up the necessary currency of self-definition, the essential landmarks with regard to which its members must position themselves.

These remarks might suggest that in my view we should abandon any pretense of objective inquiry and admit the merely partisan force of the term *Romanticism*. Eminent people have indeed gone this way before. Think, for example, of Stendhal's bon mot in his *Racine et Shakespeare*:

> Le romantisme est l'art de présenter aux peuples les oeuvres qui dans l'état actuel de leurs habitudes et de leurs croyances, sont susceptibles de leur donner le plus de plaisir possible. Le classicisme leur présente la littérature qui donnait le plus grand plaisir à leurs arrière-grandpères.[4]

> [Romanticism is the art of presenting people with works that in the present state of their habits and beliefs are able to give them the greatest possible pleasure. Classicism presents them with

[3] Lovejoy himself believed that the right approach is to factor so-called Romanticism into all the disparate movements that the term has covered and to study each of these "Romanticisms" independently. This is certainly a worthwhile enterprise and provides a useful historical basis for the more philosophical approach that I pursue here.

[4] Stendhal, *Racine et Shakespeare* (Paris, 1824), ch. 3.

the literature that gave the greatest pleasure to their great-grandfathers.]

But sloganeering with *Romantic* is not the approach I favor, either. Between the two extremes mentioned so far, there lies a middle way. While accepting Lovejoy's point about the disparate character of all that is conventionally called *Romantic*, we may still seek to figure out what Romanticism really was, if we understand this enterprise as one of *selective redefinition*, identifying and systematizing those elements of what has counted as Romantic that are important for our own concerns. So long as the defining features belong *centrally* to a *significant subset* of what is conventionally termed *Romantic*, and so long as we recognize that our selection expresses *our own interests*, there is a legitimate sense in which we are describing the "nature" of Romanticism. We are not, of course, uncovering what Romanticism was "in itself." But we are determining what it means for us. As Goethe wrote,

Was du ererbt von deinen Vätern hast,
Erwirb es, um es zu besitzen.
(*Faust* 1.682–83)

[What you have inherited from your fathers, earn it anew, in order to possess it.]

Such is the method I adopt in these pages, which present therefore an appropriation of our "Romantic legacy." The aim is philosophical rather than simply historical, as I focus more on what we ought to make of Romanticism than on what Romanticism has made of us. I shall not be interested primarily in tracing the influence of Romanticism upon contemporary culture. I propose instead to draw out, from what has come down to us as Romanticism, those central strands that *ought* to figure in the fabric of our own self-understanding. For the Romantic legacy is an inheritance we have still to make our own. No doubt Romantic themes have shaped our thought and experience in manifold ways. But we have yet to see clearly their true promise. This is so, particularly because certain standard views of Romanticism, shared by present-day opponents and enthusiasts alike, have kept us from grasping its most important insights. My leading objective is to dispel the authority of these misconceptions, and I have chosen the themes of my three chapters—"Imagination," "Community," and "Irony and Authenticity"—with this iconoclastic purpose in mind. The result, I hope, will be a somewhat heterodox picture of Romantic art and thought.

To some, this account will probably appear to be a domestication of Romanticism that leaves aside the outlandish and dangerous ideas that the Romantic movement also unleashed. The charge is not unfounded. I have indeed been chiefly con-

cerned to reclaim those elements of the Romantic legacy that I believe we ought to make our own. Yet I have also not skipped over the difficulty or fragility of these very ideas, or the pernicious use to which Romantics themselves sometimes put them.

The Romantic Legacy

❧

ONE

IMAGINATION

In this first chapter, I will look at the single most significant notion in the Romantic vocabulary—the imagination. My approach will be indirect, beginning with what I consider the most important and insightful attack on the Romantic Movement, an attack whose guiding assumptions, strange as this might seem, equally shape the positive enthusiasm for Romanticism expressed in much of present-day aesthetic and critical theory. These assumptions form, I shall argue, a formidable obstacle to a just appreciation of the Romantic imagination.

Imagination and Reality

The critique of Romanticism to which I refer finds its finest expression in the writings of two self-styled "neoclassical" thinkers in the early part of this century—T. E. Hulme in England and Carl Schmitt in Germany. The character and primary interests of these two were, of course, very different. Hulme was an aesthetician and philosopher who died tragically in World War I, whereas Schmitt was a political theorist who just as tragically went on to disgrace by becoming one of the intellectual apologists of the Nazi regime. But Hulme's *Speculations* and Schmitt's *Politische Romantik*, both published just after the Great War, join in a common indictment of Romantic thinking.[1] Both argued that Romanticism consists essentially in a *confusion of orders*, a failure to respect the objective differences of nature and standards of relevance that govern reality.

Hulme's tag for Romanticism was that it is "spilt religion."[2] By this he meant that it characteristically ignores the discontinuities among the three distinct orders of mechanism (that is, inanimate nature), life, and absolute value, and assigns to humanity religious predicates such as perfectibility and infinity that really belong to the third realm of absolute value. Classicism, by contrast, recognizes that perfection, infinity, and

[1] T. E. Hulme, *Speculations* (London: Routledge & Kegan Paul, 1924); Carl Schmitt, *Politische Romantik* (Berlin: Duncker & Humblot, 1919).
[2] Hulme, *Speculations*, p. 118.

value in general have their locus not in humanity but in an order independent of it. In contrast to the Romantic trust in perfectibility, Hulme insisted, we should recognize the existence of "original sin," that is, humanity's limits. Decrying the Romantic thirst for identification with the infinite, he declared, "It is essential to prove that beauty may be in small, dry things."[3]

As I shall try to show, there is a great deal wrong with the conventional idea, here repeated by Hulme, that Romanticism involves essentially a transcendence of the everyday and a faith in human perfectibility. It was, in fact, Romantic thinkers and artists who worked out much of the basis on which today we distrust such ideas. But despite his deference to cliché, Hulme does seem to me to be on the track of something important about the nature of Romanticism. There is, among the Romantics, a resistance to the idea that reality has a given structure, consisting in a tidy division of realms and relevancies, which the mind has but to mirror and respect. The mind is instead understood in terms of its creative power, our notion of reality is seen as rooted in the imagination, so that our mission—that of the artist, but also the task of us all—is to transform what we are given in experience. And this may entail making whole what has been broken asunder, pursuing *correspondances* where divisions were thought to exist, indeed cultivating a *romantische Verwirrung*

[3] Hulme, *Speculations*, p. 131.

(romantic confusion), as Friedrich Schlegel, the great Romantic aesthetician, liked to say.

More clearly perhaps than Hulme, it was Carl Schmitt who saw that this exaltation of the imagination underlay the Romantic "confusion of realms." Romanticism, he charged, is essentially a *subjective occasionalism*. It effectively secularizes Nicolas de Malebranche's theological occasionalism, the seventeenth-century doctrine that denied causal powers to anything in the world in order to house them in God alone (what we ignorantly call one thing causing another is really, Malebranche argued, but the one thing being an "occasion" for God to bring about the other; anything else would be a denial of God's dominion over his creatures). The Romantics' "subjective" occasionalism, said Schmitt, puts humanity—or, more exactly, the artist—in the place of Malebranche's God. Refusing to acknowledge the demands that reality places upon thought, they see the world as but the occasion for the artistic mind to assert its sovereignty. Reality counts only as a pretext for the imagination to express itself, to make up how it would like things to be, to "aestheticize." For the Romantic, Schmitt writes, "everything becomes an occasion for anything."[4] The confusion of realms is not a Romantic inadvertence but rather the intended result.

Schmitt's dismissive attitude toward Romanticism is clear enough. Contrary to the usual history of ideas, he declared,

[4] Schmitt, *Politische Romantik*, p. 24.

there were not, and could not have been, any important Romantic discoveries about the social world. (The point of Schmitt's title was that *political Romanticism* was really a contradiction in terms.) The Romantics were not the originators of historical consciousness, as often supposed. They were neither architects of modern individualism nor heralds of more collectivist modes of thought. Citing the example of Schlegel's dramatic switch of allegiance from the French Revolution to Metternichian Reaction, Schmitt argued that Romanticism was in itself no more revolutionary than traditionalist. The Romantics simply trumpeted the new when they were young and championed the old when they grew older. In Schmitt's eyes, no more revealing expression of their outlook could be found than Novalis's statement (*Blüthenstaub* [Pollen] #66) that reality is but "der Anfang eines unendlichen Romans" [the start of an unending novel].[5] The world was merely an excuse for them to spin their wheels. Talk, not decision, was their way of life, for decision requires responding to the way things objectively are. "The root of romantic sublimity," he wrote, "is the inability to make a decision."[6]

The heart of Hulme's and Schmitt's critique of Romanticism is thus that it constitutes a colossal substitution of the unfettered imagination for a proper sense of reality. Their own

[5] Novalis [Friedrich von Hardenberg], *Werke*, ed. Hans-Joachim Mähl (Munich: Hanser, 1978), 2:253.

[6] Schmitt, *Politische Romantik*, p. 162.

"neoclassicism" did not aim at a denigration of art. But they did despise the wholesale aestheticization of reality that denies the generic difference between art and other forms of thought. And in the realm of art itself, they rejected the glorification of the artist's personal point of view, which exalted his creativity at the expense of the artwork's representational function.

The criticism is not really new. In essence it appears already in William Hazlitt, a disillusioned Wordsworth worshipper, who in 1818 wrote a biting attack on the aesthetic egotism he found in his erstwhile hero. Wordsworth, he wrote,

> is jealous of all excellence but his own. He does not even like to share his reputation with his subject; for he would have it proceed from his own power and originality of mind. [He] is slow to admire anything that is admirable; feels no interest in what is most interesting to others, no grandeur in anything grand, no beauty in anything beautiful. He tolerates only what he himself creates. . . . He sees nothing but himself and the universe.[7]

The portrait is obviously meant to be unflattering. But, interestingly, the same picture of the Romantic megalomaniac, his imagination devouring all sense of independent reality, also informs some of the positive reevaluation of Romanticism current in literary theory today. Think of Harold Bloom's famous

[7] William Hazlitt, "On the Living Poets" [1818], in *Selected Writings*, ed. Ronald Blythe (London: Penguin, 1970), p. 218.

notion of what he calls the "strong," paradigmatically Romantic poet whose art aims essentially, in a sublime reversal of time and reality, to recast his influential precursors as the objects of his very own influence.[8] Or of Paul De Man's thesis that Romanticism aims essentially at "poetic transcendence," the substitution of "poetic" for "empirical" consciousness, the Romantic poem being, self-referentially, but "a particular version of the understanding that a poetic consciousness has of its own specific and autonomous intent."[9]

Creative-Responsive Imagination

Despite the variety and reputation of its proponents, I think this view misses something of the greatest importance in the Romantic idea of the imagination, at least as we find it expressed in its most memorable examples, which ought after all to be our guide. Yes, the Romantic artist does set out to poeticize the world. As Novalis wrote,

> Die Welt muss romantisiert werden. . . . Indem ich dem Gemeinen einen hohen Sinn, dem Gewöhnlichen ein geheimnisvolles Ansehen, dem Bekannten die Würde des Unbekannten, dem Endlichen einen unendlichen Schein gebe, so romantisiere ich es.[10]

[8] Harold Bloom, *The Anxiety of Influence* (Oxford: Oxford University Press, 1973).
[9] Paul De Man, *Romanticism and Contemporary Criticism* (Baltimore: Johns Hopkins University Press, 1993), p. 55.
[10] Novalis, *Werke*, 2:334.

[The world must be romanticized. . . . Insofar as I give the commonplace a higher meaning, the ordinary a mysterious appearance, the familiar the dignity of the unfamiliar, and the finite the air of the infinite, I romanticize it.]

But this poeticization of reality does not set the artist apart from the rest of humanity, in Promethean splendor. The point is rather that we all poeticize reality already, and that indeed our sense of reality, and of the claims it makes on us, is inseparable from the creative imagination. As Novalis said in full, "Die Welt muss romantisiert werden. So findet man den ursprünglichen Sinn wieder" [Thus we recapture its original meaning].

To see this, consider, for example, Wordsworth's poem *Michael* (1800). His ancestral farm burdened by debt, the old shepherd Michael must send his beloved and upright son Luke to London to earn the necessary money, but Luke succumbs to the temptations of the city and must leave England in disgrace. Michael, impoverished and brokenhearted, eventually dies, and his farm is sold off and razed. The poem lifts this series of events, "homely and rude" (35), of a sort all too common in the history of rural economy, to the heights of universal significance, becoming a moving meditation on disappointment and mutability—those great Wordsworthian themes. But is that all that this elegy *Michael* does? Is one man's misfortune but the occasion for a display of Wordsworth's ability to transform the prose of the world into poetry?

No. From the outset to the very end, Wordsworth's poem takes as its central object of attention not so much Michael's fate as the "straggling heap of unhewn stones" (17), which is all that remains of his farm. These stones compose the sheepfold that Michael began with Luke the evening before his departure for London and that he continued to build during Luke's absence and until his own death. Michael describes to Luke this stonework as "an emblem of the life thy Fathers lived" and "a covenant . . . between us" (420, 424–25): it is the expression he gives to his hopes and eventually to his loss. Michael's sheepfold is, in short, *his poem*. It is the work that his imagination fashions from his life and that outlives him. In his own poem, Wordsworth does not therefore use reality as merely a pretext for the imagination, "tolerating only what he himself creates," as Hazlitt would complain (to be echoed by Hulme and Schmitt). On the contrary, his aim is to bring out what unites him and his subject, Michael—the role of the creative imagination in the constitution of reality itself, in the articulation of the meaning of our existence, and in the achievement, against life's changes and defeats, of whatever permanence we can enjoy.

None of this is to deny what also distinguishes the poet and his subject. The work of the imagination is self-aware in Wordsworth's poem *Michael* as it clearly is not in Michael's construction of the sheepfold. Not Michael, only Wordsworth can explain the significance of this shepherd's life and its emblem. It would be wrong to suppose, however, that this dif-

ference acts to remove the poem to a separate realm of "purely aesthetic" value. The poet is indeed more self-conscious than the shepherd and turns the imagination to art, as most of us do not. But in just this special posture of the poet lies the mission to humanity that Wordsworth, like so many of the great Romantics, believed he had. What sets him apart is what directs him to the world. The poet's calling is to show, as only he can, the centrality of the imagination to our lives.

Wordsworth's use of "pedestrian" subjects such as the shepherd Michael to express his conviction that the creative imagination unites, rather than distances, the poet and humanity is what gives his poetry its special moral power. For many since the nineteenth century, Wordsworth has seemed to be a healing force, "the poet of unpoetical natures," as J. S. Mill fondly called him in his *Autobiography* (ch. 5). Wordsworth's example shows how wrong it is to suppose that the Romantic imagination must aim ultimately at the sublime. He stands rather for the recovery of *the magic of everyday life*. Such, indeed, were the terms in which Coleridge described Wordsworth's talents in his account of their division of labor in the *Lyrical Ballads*, which they published together in 1798. "It was agreed," Coleridge wrote,

> that my endeavours should be directed to persons and characters supernatural. . . . Mr. Wordsworth, on the other hand, was to propose to himself as his object to give the charm of novelty to things of every day, and to excite a feeling analogous to the

supernatural, by awakening the mind's attention from the lethargy of custom and directing it to the loveliness and the wonders of the world before us.[11]

The most important lesson to draw from Wordsworth, however, is that there is something quite wrong in supposing, be it approvingly or not, that Romanticism promotes the imagination as the organ of poetic transcendence, as the means of art's triumph over reality. For the idea that it is the imagination that gives us our fullest sense of reality figures in other Romantic writers, too, who are otherwise very different from Wordsworth and do not share his affection for the everyday. We find it, for example, even in so deliberately anti-Wordsworthian a poem as Shelley's *Mont Blanc* (1817), which mocks Wordsworth's belief that the imagination reconciles us to the world in an attitude of natural piety (79). Even though he evokes the bleak brutality of Mont Blanc in order to ruin any pretense of feeling at home in the world, Shelley remains convinced that the human imagination draws its creative force not from itself alone but from the power it feels at work in the world. As he announces in the first lines of the poem,

The everlasting universe of things
Flows through the mind, and rolls its rapid waves,
Now dark—now glittering—now reflecting gloom—

[11] S. T. Coleridge, *Biographia Literaria*, ch. 14.

> Now lending splendor, where from secret springs
> The source of human thought its tribute brings
> Of waters—*with a sound but half its own.*
> (1–6)

Indeed, the poem *Mont Blanc* conceives and legitimates the imagination's visionary power as precisely the expression of the primacy of power over order that makes up the nature of reality itself,

> The secret Strength of things
> Which governs thought, and to the infinite dome
> Of Heaven is as a law.
> (139–41)

Nonetheless, however inadequate it may be, the idea that the Romantic imagination aims to substitute art for reality does not miss its mark entirely. Tendencies and examples can easily be drawn from Romantic thought and art to bear out this conception. Looking at the broader historical context, we can see that the disappointment of the revolutionary aspirations with which many important Romantic figures allied their work in the 1790s often led not just to a sympathy with the forces of political reaction but also to a certain internalization of their aesthetic goals. Art came to appear a refuge from reality. Perhaps books 10–13 of Wordsworth's *Prelude*, which recount the restoration of the

poet's imagination after his misguided enthusiasm for the French Revolution, can be read, to some extent, in this way. Certainly Keats's *Ode to a Nightingale* (1819) has seemed to many to fit this mold, as when he addresses the promise of art (that is, the nightingale's song) in these terms:

> That I might drink, and leave the world unseen,
> And with thee fade away into the forest dim:
> Fade far away, dissolve, and quite forget
> What thou among the leaves hast never known,
> The weariness, the fever, and the fret
> Here, where men sit and hear each other groan.
> (19–24)

If at the end of the ode Keats sadly concludes that "the fancy cannot cheat so well / As she is famed to do" (73–74), it is not, it seems, because he has changed his mind about the reality-transcending function of the artistic imagination. He appears only to have modified his estimate of the extent to which one can identify with it.

With evidence such as this in mind, M. H. Abrams wrote an important study some years ago entitled *The Mirror and the Lamp*, arguing that this is precisely how we should understand the essence of Romanticism.[12] The Romantic work of art, he asserted, no longer aims to be a *mirror*, shining by reflected light

[12] M. H. Abrams, *The Mirror and the Lamp* (Oxford: Oxford University Press, 1953).

(as according to older, mimetic theories of art), but presents itself instead as a *lamp*, shining by its own light, which is the creative power of the productive imagination. Abrams thus shares the same fundamental conception of Romanticism as Hulme and Schmitt, though what they condemn he only admires. In this, he is like Harold Bloom, and indeed his later definition (in *Natural Supernaturalism*) of Romanticism as the secularization of traditional theology, the replacement of God by the poetic mind as creator of the world,[13] is but another set of words to describe what Bloom calls the "strong" poet, who redefines reality to suit the needs of the imagination.

Evidence can certainly be mustered to support this conception. And, as I pointed out in the introduction, no account of Romanticism can pretend to be more than a selective redefinition. Nonetheless, I believe there are good reasons not to follow this route and instead to take Wordsworth's *Michael* as our guide. The imagination as we find it at work in this poem is a complex faculty, neither mirror alone nor lamp alone, but rather both together. *Michael* presents a poetic intensification of "homely and rude" events, yet this transformative vision operates by focusing on the work of the imagination in Michael the shepherd himself. The imagination is *creative and responsive at once*—and not just in Wordsworth's attitude toward Michael but also in Michael's own activity, guided as it is by his love and fears for his son Luke.

[13] M. H. Abrams, *Natural Supernaturalism* (New York: Norton, 1971), p. 13.

This is Wordsworth's conception generally. Thus at the very beginning of *The Prelude*, his poetic autobiography, he proclaims that it is in response to a "gentle breeze" from without (1:1 [1805 edition]) that his poetic powers are aroused within, "a corresponding mild creative breeze" (35), which, though swelling into "a tempest, a redundant energy" (38), would be nothing without that first "animating breeze" (7:2). This idea of the imagination is also, as I suggested before, far from being a peculiarity of Wordsworth's own aesthetic of reconciliation with nature. It equally shapes the outlook of Romantics such as Shelley, for whom the imagination must spoil any sentiment of being at home in the world, not because it transcends reality but because it resonates with the fundamental inhospitality, the untamable power of reality itself.

In short, this view of the imagination is one that undoes the supposed dichotomies—between creative and responsive, expressive and mimetic, imagination and reality—that structure the outlook of those modern critics and enthusiasts of Romanticism that I have been citing. Why do I favor putting this view at the center of our conception of Romanticism? Not just because it is more complex, though complexity does have an intrinsic fascination for philosophers. More important, it is a view of greater explanatory power. Without it, we cannot discern the central preoccupation of the greatest Romantics, nor understand the inner fragility of the Romantic Movement and the array of alternatives that its demise left behind. Reflecting

indeed on the subsequent course of Western art and the signs of exhaustion it has come to show, we have every reason, I think, to want to work back to this view of the imagination.

Fragility of the Romantic Synthesis

To appreciate the strengths of the thesis I propose is—odd as this may sound—to see precisely how the creative-responsive imagination can prove a fragile, even elusive phenomenon to grasp. Its two dimensions, however compatible they may be (as the poem *Michael* shows), are ready enough to pull apart. The visionary power of the imagination can all too naturally expand to the point of seeking to rewrite the world in its own language. And those with a healthy sense of reality can all too understandably conclude from this that art is either a thing of the past, or a mere pastime, or at best a useful tool for social-political causes. With the death of the Romantic Movement, announced by so many different writers by the mid-nineteenth century, precisely such a dissociation sets in. Romanticism splits asunder into the aestheticism of *l'art pour l'art* and the realism of *il faut être de son temps*, and all their various versions ever since.[14] It cannot be said that the arts themselves have gone on to flourish under these ideological conditions.

The notion of the Romantic imagination that I have rejected—namely, the poetic transcendence of reality—properly belongs, therefore, among the ruins of the Romantic syn-

[14] Cf. Hugh Honour, *Romanticism* (New York: Harper & Row, 1979), p. 319.

thesis, a synthesis that tended from the outset toward collapse. No wonder, then, that the "degenerate" form of the imagination, in which it becomes the antagonist of reality, posed the inherent temptation and abiding danger of which the greatest Romantics were themselves all too aware and which they sought to avoid. No more powerful and prophetic expression of this concern can perhaps be found than in Balzac's novella *Le chef-d'œuvre inconnu* [The Unknown Masterpiece] (1831/1837).

It is the story of Maître Frenhofer, an aged painter of genius, who has worked for ten years on his magnum opus, the portrait of a woman, which he refuses to show to anyone. His artistic credo is "la mission de l'art n'est pas de copier la nature, mais de l'exprimer" [the mission of art is not to copy nature, but to express it], an ambiguous formula that he unmistakably narrows, however, in the direction of seeing his art as a "lutte avec la nature" [struggle with nature].[15] Frenhofer cherishes his painting exactly as he would a mistress, refusing to prostitute it by exhibiting it to the world, and indeed in the very same way that, in this story, the young Nicolas Poussin hesitates to lend Frenhofer his own beloved and superlatively beautiful mistress, Gillette, as a model. When in the end the Maître has had his private studio session with Gillette and displays his finished painting, Poussin finds nothing but a confused mass of colors and lines, with only the tip of a foot recognizable. The triumph of

[15] Balzac, *Le chef d'œuvre inconnu. Gambara. Massimilla Doni* (Paris: Garnier-Flammarion, 1981), pp. 48, 56.

imagination over reality, of art over love—far more beautiful, Frenhofer is convinced, than his final model, the most beautiful woman in Paris—ultimately yields, in Balzac's apt phrase, "une muraille de peinture."[16] Painting has closed itself off from the world.

Critics argue about whether Balzac meant Frenhofer to express the Romantic aesthetic of his friend Delacroix. I think the proper verdict is that, for Balzac, Frenhofer represented a danger to which the Romantic cult of the imagination could well succumb, though not necessarily. It was a threat that we, at least, may say that Delacroix himself successfully resisted. True, in his *Journal* (May 14, 1824) Delacroix could write such things as "La nouveauté est dans l'esprit qui crée, et non pas dans la nature qui est peinte" [Novelty is in the mind which creates, and not in nature which is depicted]. But characteristically his painting gives a different impression. Consider, for example, his *Abduction of Rebecca* (1846), a scene from Sir Walter Scott's *Ivanhoe*, located at the Metropolitan Museum in New York (see plate). Here as elsewhere in Delacroix, color and light dissolve the distinctness of forms, yet not at the expense of what is depicted. On the contrary, the radiance of the fire moves along the lines of the dramatic action (down the path from the burning castle to the moors and the knights making off with Rebecca) to merge with the incandescent sunlight bursting from the upper left-hand corner down upon Rebecca,

[16] Balzac, *Le chef d'œuvre inconnu*, p. 69.

so that technique and subject fuse into a single, energetic movement. This is a painting that, unlike Frenhofer's, joins us to the world rather than walling us off. It says a lot about the subsequent development of aesthetic thought and experience that in our century André Breton, the father of Surrealism, found it natural to thwart Balzac's intention and to hold up Frenhofer as the model to follow.[17]

Among the Romantics themselves, the aestheticism of a Frenhofer, where it is expressed, figures generally as an extravagance or as a desperate fallback position, designed to give art some function in the face of a reality considered alien to the imagination, and not as a program unreservedly espoused. Sometimes it plays a qualified role in a broader conception of art. This, in fact, is how I believe we should understand Keats's *Ode to a Nightingale*. Certainly the poem evokes the transcendence of reality through art, but it does not ultimately identify itself with this project or its failure, as expressed in the lines near the end—"The fancy cannot cheat so well / As she is famed to do." The poem concludes instead with a larger and subtler view of the imagination. As we learn from his letters, Keats did not believe the proper response to the tragedy of life, "where men sit and hear each other groan," lies in fleeing it for some kind of certainty or solace. He looked rather to that character of mind he famously called "Negative Capability," in which we are "capable of being in uncertainties, Mysteries,

[17] André Breton, *Le surréalisme et la peinture* (Paris: Gallimard, 1965), p. 52.

doubts, without any irritable reaching after fact & Reason."[18] This refusal of escapism must apply to art as well. And indeed, Keats saw poetry as the supreme expression and teacher of negative capability, precisely because the form and meaning that art lends to the human condition and its suffering are *imagined*—that is, suggestive rather than certain, and so always qualified by a sense of the bleaker reality that persists. This point comes out in the very last words of the poem:

> Was it a vision, or a waking dream?
> Fled is that music:—Do I wake or sleep?

Such questions are not an admission of the imagination's defeat by reality. Nor, of course, do they signal the imagination's triumph. These lines express just that uncertainty about the power to redeem reality that Keats thought the life of the imagination, if true to its own "negative capability," must acknowledge. Even the *Ode to a Nightingale*, despite its evident sympathy for the idea of escaping reality through art, comes round in the end to a deeper, more responsive and less aestheticist, sense of the imagination.[19]

The complex view of the Romantic imagination that I propose is a more dynamic conception than the one usually

[18] John Keats to George and Tom Keats, December 21, 27?, 1817, *Letters*, ed. Robert Gittings (Oxford: Oxford University Press, 1970), p. 43.

[19] For a fine discussion of the limits of Keats's "aestheticism," see F. R. Leavis, *Revaluation: Tradition and Development in English Poetry* (London: Stewart, 1936), ch. 7.

assumed. Instead of freezing Romanticism into a settled doctrine (which is what the presumed antagonism between imagination and reality must be), it recovers the kind of struggle in which the Romantic project essentially consisted. It brings out the sort of problems the Romantics sought to solve, the temptations they tried to avoid. More often than not, the evidence that seems to corroborate the contrary, aestheticizing idea of the Romantic imagination stems from what was experienced as failure or surrender, or (as in the case of Keats) forms part of a larger vision.

Philosophical Excursus

By this point, the reader may feel a bit breathless and somewhat dissatisfied with the course my discussion of the Romantic imagination has taken. Though it would be fine, one might agree, to be possessed of a faculty that is at once creative and responsive, just what *is* this imagination? What is its characteristic mode of operation? How is it related to our other mental capacities? How can it play a constitutive role in both art and life, so that—as I have argued the Romantics realized—there can be no fundamental opposition between imagination and reality? These are important but very difficult questions. The best I can do here is to offer a rudimentary view of what in general the Romantics meant by the imagination and then indicate one distinctive way in which they brought out its dual, creative-responsive function.

There are two ordinary senses of the word *imagination*,

which clearly do not capture what the Romantics meant by the imagination. It is not *visualization*, that is, simply the conjuring up of an image of something, in the absence of the thing itself. Nor is it *association*, or the mental combining of items that in the world or in previous experience have not been found to be connected. These two capacities may well form necessary elements of the Romantic imagination, but they do not embody what is most distinctive of it. The essential work of the imagination lies rather, I would say, in the *enrichment of experience through expression*. The idea is that, as the imagination is more creative, so our feelings, beliefs, and desires achieve expression in forms that are fuller in implication and resonance than what our lives would otherwise be.

Typically the Romantics considered the imagination, so understood, not as one mental faculty among others, and certainly not as merely the organ of make-believe, but rather as the very essence of the mind. Kant (not much of a Romantic himself!) was so influential for Romantic thought because of his view that the mind is essentially active, not merely registering but rather structuring what we call reality. It is no accident that Romantic philosophers such as F. W. Schelling proposed to redraw Kant's picture of the mind around the focus of the so-called productive imagination. Whether the activity be storytelling or describing the laws and mechanisms of the natural world, the mind, they maintained, does not operate by conjoining given images or data, as the sensualistic philosophies of the

Enlightenment (Hume, Condillac, Helvétius) suggested, or by intuiting the objective order of the world, as the more rationalistic forms of early-modern thought supposed. The mind works instead by constructing forms of expression, so that the very idea of there being "immediate" objects of sense and reason is incoherent. What we call reality is not an order of the world that the mind has only to reflect; it is an image of the way things are that the mind projects. The mind responds to the world only by at the same time creating its own forms of understanding. That is why the Romantics viewed the mind as quintessentially the imagination as they understood it.

Such was the line of thought by which the Romantics promoted the imagination from its previously secondary status—"decayed sense" is what Hobbes termed it—to the role of central, organizing principle of the mind, "the living power and prime agent of all human perception," as Coleridge (*Biographia Literaria*, ch. 13) wrote, or "la reine des facultés, [qui] touche à toutes les autres, [qui] les excite, [qui] les envoie au combat" [the queen of the faculties, which is involved in all the others, (which) incites them, and (which) sends them into combat], in Baudelaire's words.[20] That the mind does not copy but creates, and only through the imagination lays hold of reality, will perhaps strike some as by now old news. That is not a reason to forget that it has not always been so and that it is an

[20] Charles Baudelaire, "Salon de 1859," sec. 3 in *Oeuvres complètes* (Paris: Gallimard, 1961), p. 1037.

insight we owe to the Romantics most of all. And one that it is still possible to lose, as Hulme and Schmitt show.

Time and Vision

One of the most profound and characteristic ways in which this creative-responsive nature of the Romantic imagination is expressed is through what could be called the essential *temporalization* of the Romantic imagination.

Things primordial and ultimate, the effulgence of the living God, the reconciliation of mind and nature—for the Romantics such supreme realities were certainly a continual and distinctive focus of attention, the magnetic pole of visionary experience. Yet it is striking how seldom Romantic thought and art claim to capture them in their full presence or complete achievement. Far more characteristically, these phenomena figure as the objects of memory or anticipation, as what has once been or may yet be, not as the flesh and blood of present experience. The vision is almost always one of retrospect or expectation, the unalloyed presence of its object being assumed to be such as to defy speech or understanding.

This attitude of reserve is not, I am convinced, accidental. Precisely through being at once creative and responsive, the imagination can articulate a sense of ultimate reality only along the dimensions of past and future. Present experience as such is more than possible, of course. But visionary experience, seeking as it does to escape the hold of every conventional notion

of its object, cannot find its voice in the present. There must be a stepping back, to devise the terms for its expression, so that the vision itself appears as one remembered or as one that may come again. Even in its most ambitious moments, the Romantic imagination exemplifies the terms of human finitude.

This "temporalization" of the imagination governs, for example, the work of Friedrich Hölderlin, the very epitome of the Romantic visionary, consumed by his vision to such a point, it seems, that after writing probably the most powerful poetry ever composed in the German language, he lapsed into madness for the last forty years of his life. The disclosure of the divine forms the guiding theme of Hölderlin's poetry and, indeed, in his view, the essential calling of poetry in general. Yet literally in the very center of his greatest elegy, *Brod und Wein* [Bread and Wine] (1800–1801), he announces that the presence of the gods (*die Himmlischen*), when it occurs, and so long as it lasts, is too bright, too blinding for human beings, and even poets, to speak or make anything of it:

> Unempfunden kommen sie erst, es streben entgegen
>> Ihnen die Kinder, zu hell kommet, zu blendend das Glück,
> Und es scheut sie der Mensch, kaum weiss zu sagen ein Halbgott,
>> Wer mit Namen sie sind, die mit den Gaben ihm nahn. (5:1–4)

> [Unperceived at first they come, and only the children
> Surge towards them, too bright, dazzling, this joy enters in

So that men are afraid, a demigod hardly can tell yet

　Who they are, and name those who approach him with gifts.]

(trans. M. Hamburger)

Or, as he observes in *Dichterberuf* [The Poet's Calling, 1801], when the divine comes over the poet, he can but remain mute (*stumm*, 22), and his limbs tremble (24). Only by distancing himself from the divine presence can Hölderlin's poet put into words what has been made manifest to him. This step back takes, moreover, a temporal form, the poet's relation to the divine becoming one of remembrance or anticipation. Only by recalling a past Coming (in *Brod und Wein*, Hölderlin refers to Dionysus and Christ) or by heralding a future Revelation yet to come (and that is the purpose of this poem), can the poet find his tongue and fulfill his mission. In *Brod und Wein*, it is the image of "holy night" (*heilige Nacht*) that expresses this essential situation, the pregnant absence of a divinity that "sonst dagewesen und kehrt in richtiger Zeit" (8:16), that "once was there and will come again when it is time." Here, as elsewhere in Hölderlin, the poet's vision is necessarily decentered from the present, drawn along the lines of past and future.

Hölderlin accordingly sees two dangers to which the poet is exposed. He may try to storm the divine presence, pretending that his poetic vision captures its very essence. Or he may be himself so captured by its brilliance that he cannot muster the strength to back up and translate it into words. (Perhaps this

second sort of failure has something to do with Hölderlin's own later madness.) Either way, the poet fails to appreciate the paradoxical truth with which Hölderlin concludes his poem *Dichterberuf*—"Gottes Fehl hilft."

That "God's absence helps" should be the credo of a visionary poet is puzzling, only if we forget that poetic vision, too, must be for a Romantic like Hölderlin an act of the imagination, which responds by at the same time creating. What the poet has seen he cannot articulate except by standing back, giving it a form that shapes and extends the experience beyond its felt immediacy. Paul De Man put his finger on the mark when he observed that Hölderlin's poetry (which he rightly took as representing Romantic art at its purest) is essentially "non-apocalyptic," not possessed with the ambition of being at one with the ultimate ground of Being but instead propelled by the achievement of poetic distance, the "non-coincidence of sign and meaning."[21] But De Man betrayed this insight when, in keeping with the aestheticist interpretation of Romanticism that I have criticized throughout this chapter, he went on to equate poetic distance with "poetic transcendence," the triumph of art over "objective reference." The Romantic imagination is a more complex constellation than such phrases can suggest. It is at once creative and responsive, distanced and attuned, and indeed the one only by way of the other. De Man was blind to the receptive moment of the

[21] De Man, *Romanticism and Contemporary Criticism*, pp. 13, 71, 163.

Romantic imagination and hence powerless to explain why in *Dichterberuf* Hölderlin contrasts the poetic hubris that reaches for the very being of the divine with the proper attitude (not of an "active forgetting," as De Man would have to suppose, but) of thankfulness:

> Doch es zwinget
> Nimmer die weite Gewalt den Himmel.
> Noch ists auch gut, zu weise zu sein. Ihn kennt
> Der Dank.
> (55–58)

[Broad power can never compel Heaven. Nor is it good to be too knowing. It is gratitude that knows Heaven.]

For Hölderlin true poetry is possible only because of the presence of the divine, but never in the midst of the divine presence itself. If the poet can give expression to this presence only as something past or future, this signals not just the extent to which the creative imagination goes beyond its source but also the extent to which it remains responsive to it as to an authority lying outside its present control.

If time permitted, we could explore a similar temporalization of the Romantic imagination in other great visionary poets of the period. Wordsworth's *Immortality Ode* (1807), for instance, moving back and forth in successive stanzas between

the child's unthinking oneness with nature and the rupture that the maturing mind inevitably requires, builds to the insight that the lost unity lives on in the imagination in the mode of being remembered:

Though nothing can bring back the hour
Of splendour in the grass, of glory in the flower;
 We will grieve not, but rather find
 Strength in what remains behind.

(180–83)

But instead of pursuing further examples, I want to close by returning to the main thesis I have tried to prove in this chapter. Contrary to some of its most important critics and champions alike, the Romantic imagination does not view the world as but a pretext for self-expression or seek to transcend it in the direction of the autonomy of art. It is instead creative and responsive at once, opposed to any cut-and-dried opposition between imagination and reality. I have surely been unable to conceal my own affection for the idea of art that it embodies—or my dismay at the aestheticism the abandonment of it has entailed.

More than the fate of art, however, hangs in the balance. The Romantic imagination, as I noted earlier, has played a formative role in our understanding of the relation between mind and world generally. Here, too, the tensions inherent in

its dual nature have given rise to the same one-sided exaggeration typical of much post-Romantic aesthetics. The creative moment has all too often overpowered the responsive. Knowledge has come to seem more a matter of invention than discovery, and reality simply an image that we construct, instead of also the test of our thinking. Such an outlook has its partisans in many areas of contemporary thought, and in many university departments. It is most powerfully expressed in the writings of Richard Rorty, surely the most widely influential philosopher in our fin de siècle. Rorty's guiding theme is that the mind, its shaping action inseparable from all that we can call knowledge, cannot be considered the *mirror* of nature. (*Philosophy and the Mirror of Nature* is the title of Rorty's first and justly famous book.) This is a Romantic insight, as Rorty has come to acknowledge. But he has driven it to the conclusion that the world, as something to which our thought should hold itself responsible, is a thing "*well-lost*."[22] The "Romantic idea" that he urges us to put in its place is that "truth is made rather than found."[23]

To make the Romantic legacy our own, I believe, is to resist simplifications of this sort. The task is by no means an easy one. It is difficult to keep in mind simultaneously both moments of the Romantic imagination. We will surely lose our

[22] Richard Rorty, "The World Well Lost," *Journal of Philosophy* 69 (1972): 649–65.

[23] Richard Rorty, *Contingency, Irony, and Solidarity* (Cambridge: Cambridge University Press, 1989), p. 7.

hold, for example, if we assume that some elements of our experience simply reflect the way things are while other elements express what we add. We must instead see how experience, like art, is creative and responsive at one and the same time. We must try to find a language, as did the Romantics, to capture the fact that truth is at once made and found. Only so can we respect the complexity, however fragile, of what the Romantics grasped.

TWO

୨ଭ

COMMUNITY

I have presented a picture of Romanticism that runs counter to a predominant conception shared by its champions and its critics alike. The work of the Romantic imagination, I argued, is not to flee things as they are, nor to use the world as a pretext for self-expression, nor to rewrite reality in the language of autonomous art. On the contrary, the Romantics aimed characteristically at undoing the conventional opposition between imagination and reality. In their eyes, the imagination is what unites the artist with the rest of humanity. It lies at the heart of whatever knowledge we have of reality, and even in its most

visionary moments remains at once creative and responsive, exalted yet attuned to the world.

The preceding chapter offered a uniformly positive appreciation of its object. Its goal was to recapture a Romantic insight that has the greatest importance for our self-understanding but that we are in peril of losing. This second one will be different in tone. My object remains one of drawing out those elements of our Romantic legacy that we should make our own, but this time my judgments will have to be more qualified, and my enthusiasm more circumspect. That is because my second theme represents a mixed inheritance, a force for both good and ill, a Romantic insight that we must extract from the misconceptions by which the Romantics themselves too often betrayed it.

This theme is *community*. It is something of a cliché that the Romantics introduced a new sense of the importance of belonging. Rejecting the individualistic philosophies of the Enlightenment and fearing the atomistic effects of the new commercial society that they saw emerging around them, the Romantics often showed a distrust of critical detachment, a respect for tradition, and an appreciation for the weight of history. In opposition to "mechanical" modes of analysis, they promoted an "organic" vision of society. The Romantic age saw the rise of the historical novel (as in Sir Walter Scott), with its acute attention to local color and the variety of custom. It also gave birth to modern sociology and its concern to show the dependence of individual action on social structure.

This conventional image is not wrong. But it is problematic in two regards. First, we should recognize that though it does express part of our Romantic legacy, it also fails to capture the various forms of individualism that figure just as incontestably in this inheritance. In my next chapter, "Irony and Authenticity," I will turn to exactly these aspects of Romanticism. But to forestall any charge of inconsistency, let me pick up again the remarks I made in the introduction about the approach that I am following. We cannot hope, I said, to find a useful definition of Romanticism that fits all the facts; we must rather draw out those strands of the Romantic legacy that connect with our present interests. Precisely for that reason, however, we should expect that our image of Romanticism will prove no more uniform than our own concerns. What Romanticism means for us can only be manifold, standing as it does behind, for example, our twin preoccupations with community and with individuality.

But second, we ought also to acknowledge that in fact we are rather unsure about the sense we should make of the Romantic praise of belonging. It is unclear what exactly it involves and what role it should play in our own self-understanding. Does the Romantic theme of community represent the recovery of social and moral truths that Enlightenment thought had lost? Or does it express a philosophical innovation in its own right? And in view of the deadly forces of nationalism and fascism, which have made this Romantic theme very much their own, should we not regard it as a fatal misstep of the European

mind? Or does it embody important insights that we must care-
fully distinguish from their chronic misuse? We have yet to see
our way through these uncertainties. They come out in much
of recent political and social thought, in the renewed interest
for the idea of "community," and in the controversies that this
new so-called communitarianism has sparked.[1]

These are the questions about our Romantic inheritance,
centering around the nature and value of community, that I
will now take up. In contrast to the first chapter, the materials
for this discussion will come chiefly from Romantic philo-
sophical and social thought and less from literature and the
arts. But I will not leave behind the conclusions at which I
arrived earlier. On the contrary, the creative-responsive
nature of the Romantic imagination will in the end prove
rather important to a proper understanding of our present
theme of community.

The Value of Belonging

The best guide to the Romantic discovery of community and
belonging is the thought of Johann Gottfried Herder, the late-
eighteenth-century German writer who is commonly consid-
ered one of the chief architects of modern historical con-
sciousness and the intellectual father of modern nationalism.
Herder is undoubtedly more an intuitive than a systematic

[1] The clearest expression of contemporary communitarianism is still Michael Sandel,
Liberalism and the Limits of Justice (Cambridge: Cambridge University Press, 1982).

philosopher. Yet he is no less important for that. Few thinkers have seen so deeply into the value of belonging and discerned so well its philosophical consequences.

Nowhere perhaps did Herder express more movingly the essence of his thought than at the end of the very unsatisfactory vacation he took in 1788. Wishing to imitate his friend Goethe and trade the northern mists for the land of lemon trees, Herder had made his own *italienische Reise*, traveling down nearly the whole length of Italy. The trip was a series of planning mistakes from beginning to end. But Herder fled back north to Weimar also because he realized, more viscerally it seems than ever before, that playing the citizen of the world was not for him. Sadder but wiser, he reported to Goethe from Rome, "Du taugst nicht mehr für Deutschland; ich aber bin nach Rom gereist, um ein echter Deutscher zu werden" [You are no longer suited to Germany; but I traveled to Rome, in order to become a true German].[2]

The idea is one he had been developing, in a more theoretical mode, for many years already. (His inspiration here seems to have been an older friend, Johann Georg Hamann, one of the most important, if difficult, sources of Romantic thought.)[3] A cosmopolitan ability to view the world of cultural differences with Olympian impartiality, selecting those ways of life

[2] Johann Gottfried Herder to Goethe, December 27, 1788, *Italienische Reise: Briefe und Tagebuchaufzeichnungen, 1788–1789* (Munich: Deutscher Taschenbuch Verlag, 1988), p. 293.
[3] See Isaiah Berlin, *The Magus of the North* (New York: Farrar, Strauss & Giroux, 1994).

that happen to meet one's individual needs or ideals, is not, Herder argued, a viable conception of the good life. Our highest aspiration ought not to be the stance of complete autonomy, in which we can stand back from our given social arrangements and appraise their merits in the light of historically transcendent principles. Our goal must instead be to acknowledge the concrete form of life with which our strongest commitments are inextricably entwined and to seek our self-perfection within its limits.

It is easy to trivialize Herder's conception of belonging and miss its radical significance. He did not mean simply that there exist many cultures, involving different ideas of the good life, that have an important effect on the individual mind. That is in itself an obvious observation, one that had already received systematic exposition in the hands of such Enlightenment thinkers as Montesquieu and Voltaire. Herder's concern was not with the *causal role* of forms of life but with the *kind of value* they can embody. Whatever may be the actual genesis of our moral views, Herder observed, we cannot regard our deepest beliefs about the good and the right as principles that we would in fact choose upon reflection, for we have no sense of what is valuable, and so no adequate basis for choice, without them. We must instead regard them as felt convictions, which set the terms of the choices we do make and which are embodied in the way of life that is ours. Such allegiances express not the power of autonomous choice but rather our sense of belonging. "The

blurred heart of the indolent cosmopolitan," Herder declared, "is a shelter for no one."[4]

The object of Herder's attack was the single-minded pursuit of the ideals of critical detachment and autonomous choice that, in their different ways, the French philosophes and Kant had seemed to recommend. The Enlightenment project of bringing our lives entirely under the dominion of rational control can only lead, he believed, to a loss of our moral bearings. But just as it is wrong to trivialize Herder's defense of belonging, so it is also a mistake to exaggerate it. Herder was no apologist for blind obedience. Individual autonomy has its value (not for nothing had he been Kant's student in Königsberg). Herder's point was that it cannot be made into our supreme ideal, except at the cost of our moral substance. We must strive for the right balance between critical reflection and belonging. Only so will our lives achieve what he called a *Mittelpunkt*, a center of gravity through which they can be at once expansive and rooted.

Herder's praise of belonging is not unconnected to a second important philosophical contribution, perhaps equally famous, namely, his *pluralism*. Herder believed that the same immoderate confidence in rational control that aims to turn our given way of life into one that we choose autonomously leads also to supposing that there exists one single source of value that our different moral conceptions and different ideals of the good life must variously promote or express, in order to have any valid-

[4] J. G. Herder, *Ideen zur Philosophie der Geschichte der Menschheit* (1784), book 8, sec. 5.

ity. In reality, he argued, things are not so simple. The ultimate sources of objective value are not one, but many. The point of Herder's pluralism was not to suggest that our moral and ethical commitments are ultimately arbitrary. It was rather to force recognition of the fact that the commitments we are right to affirm may entail nonetheless real and irreparable loss. That is, the possibilities we forgo may represent not simply lesser forms of the same good that our commitments embody and thus make up for, but also very different forms of good that we will miss out on altogether. For example, an ethic of unconditionally and universally binding duties, which Herder joined Kant in professing, precludes us from enjoying the intense family loyalties of a heroic ethic, whose value Herder—unlike Kant—refused to deny, even as he deemed it less great.[5]

Herder's pluralism ran no less counter to the established view of reason (and not just Kant's) than did his praise of belonging. But the theme of this chapter is community, and to that I now return. No doubt my sympathy with what Herder had to say about the value of belonging is obvious enough. I cannot present here a full-scale, systematic defense of this position. What I can do is illustrate its force by showing how inadequate was the reply that Kant, the greatest Enlightenment philosopher, made to the similar defense of belonging that

[5] On Herder's pluralism, see my "Pluralism and Reasonable Disagreement," in E. F. Paul et al., eds., *Cultural Pluralism and Moral Knowledge*, pp. 61–79 (Cambridge: Cambridge University Press, 1994), and my *The Morals of Modernity* (Cambridge: Cambridge University Press, 1996).

appears in Edmund Burke's famous *Reflections on the Revolution in France* (1790).

Kant Versus Burke

Burke's *Reflections* belongs among those rare late-eighteenth-century works that, written with little advance sympathy for the Romantic movement gathering on the horizon, nonetheless figure among the charter documents of Romanticism. (Interestingly enough, Kant's own *Kritik der Urteilskraft* [Critique of Judgment] [1790] is another example, but with regard to the theme of imagination). It is in one of the most famous purple passages of his book that Burke defends the value of belonging in the moral life against the rationalism of the French revolutionaries, thereby lending his philosophical support to the cause of the ancien régime:

> We think no discoveries are to be made in morality, nor many in the great principles of government. . . . We are afraid to put men to live and trade each on his own private stock of reason. . . . Prejudice renders a man's virtue his habit, and not a series of unconnected acts.[6]

By "prejudice," of course, Burke meant not bigotry but literally pre-judgment, or the disposition to follow accepted cus-

[6] Edmund Burke, *Reflections on the Revolution in France* (1790; Harmondsworth: Penguin, 1982), pp. 182–83.

tom, the accumulated experience of generations. It cannot be said that Burke, for all his eloquence, achieved in his rejection of moral rationalism the philosophical depth that informs Herder's writings. Nonetheless, Burke's *Reflections* became an important source for the communitarian strand of Romantic thought and a significant challenge, already in the early 1790s, to the moral rationalism of the Enlightenment.

Kant himself took up the challenge in his essay "On the Common Saying: 'This may be true in theory, but it does not apply in practice'" (1793), targeting, as he says, "a worthy gentleman who so boldly criticizes theories and systems"—that is, Burke himself.[7] Perhaps because it is a *pièce d'occasion*, Kant's reply speeds through the familiar terrain of his moral philosophy with an unusual clarity, bringing into sharp relief the philosophical gulf between him and someone like Burke, or Herder. Kant begins with the axiom that as moral beings we are subject to categorical obligations: our moral duties are binding on us, whatever may happen to be our conceptions of happiness or self-perfection, which are only too likely to vary from individual to individual. From this he infers that we must understand ourselves as having the freedom to stand back from the ideas of happiness that our experience has given us, so that we may do our duty. Duty and freedom, so understood, he then construes as a deliverance of pure reason, concluding that rea-

[7] Immanuel Kant, *Political Writings*, ed. H. Reiss (Cambridge: Cambridge University Press, 1970), p. 63.

son therefore also requires the establishment of a form of political association that respects individual liberty, instead of seeking to impose any particular, inherently controversial idea of happiness or the good life.

Duty, moral freedom, political liberty, together expressing the voice of reason—this is Kant's ethics in a nutshell. Where does it stand fundamentally opposed to the Romantic communitarianism announced by Burke and Herder? Not, as one might first think, in its defense of the republican principle of political liberty, nor in its idea of the sublimity of moral duty. Clearly Kant himself thought that those two things were at stake in his quarrel with Burke. But on this he was misled by the polemical animus of Burke's philippic. Similarly mistaken have been the countless others since Kant who have supposed that a sense of the value of belonging must be deaf to the imperative call of duty and hostile to the ideal of political liberty.

Herder's writings are particularly suited to disabusing us of these preconceptions about the Romantic theme of community. For Kant's evocation of unconditional duty and moral freedom Herder had the greatest respect. "I have enjoyed the good fortune," he wrote affectionately, "to have known a philosopher who was my teacher," Kant's most important teaching being in his eyes the doctrine that we "sense within us the unconditional demand to do what is right" as well as "the freedom to act in accord with this demand."[8] As for the ancien régime, Herder

[8] J. G. Herder, *Briefe zur Förderung der Humanität* (1793–1797), 6:79.

felt nothing but contempt. At a banquet in 1789, it seems, he openly pronounced the French court "a scabhead and the courtiers the louses that crawl over it."[9] This hatred for oppressive elites and a republican antipaternalism run through all of Herder's writings. Indeed, most of the German Romantics who picked up the rhetoric of belonging also remained, at least through most of the 1790s, firm (even explicitly anti-Burkean) partisans of the French Revolution.[10] The marriage between Romanticism and Reaction took place a decade later, and more for circumstantial than for intrinsic reasons.

No, the true crux of the Kant-Burke dispute, whatever the two of them may themselves have thought, the real controversy between Enlightenment rationalism and Romantic communitarianism centers around the appeal to reason as a self-sufficient basis for the conduct of life. At stake were not so much any particular moral or political doctrines as the proper self-understanding of those who advocate them (though the two are not always independent of one another). What did Kant believe that he added to his moral and political convictions by maintaining that both issued from reason as such? Clearly it was that his notions of moral duty and political liberty thereby earned a

[9] The incident is reported in a letter from Friedrich Schiller to C. G. Körner, September 28, 1789; see Schiller, *Briefe, Kritische Gesamtausgabe*, ed. F. Jonas (Stuttgart, 1892–1896), 2:339–40.

[10] See Frederick C. Beiser, *Enlightenment, Revolution, and Romanticism: The Genesis of German Political Thought, 1790–1800* (Cambridge, Mass.: Harvard University Press, 1992), p. 239.

warrant that no rational person could contest. But can one really draw such significant principles simply from reason alone and a general knowledge of the human situation—that is, without already assuming the validity of these or any other moral principles? Is reason really a faculty whose results can be—I daresay, miraculously—*incontestable* and *substantive* at once?

The heart of the Romantic critique of moral rationalism is that this is an impossible combination. If reason is the faculty by which we stand back from a given practice to evaluate its merits, then standing back from our way of life as a whole, in order to listen to what reason as such can say to any person as such about the conduct of life, is to find ourselves without any real guidance at all. No Romantic expressed this conclusion so powerfully as Wordsworth, who recounts in the *Prelude* (1805) his own earlier attempt to base morals in reason alone:

> Thus I fared,
> Dragging all passions, notions, shapes of faith,
> Like culprits to the bar; suspiciously
> Calling the mind to establish in plain day
> Her titles and her honours, now believing,
> Now disbelieving; endlessly perplexed
> With impulse, motive, right and wrong, the ground
> Of moral obligation, what the rule
> And what the sanction; till, demanding *proof*,
> And seeking it in every thing, I lost

All feeling of conviction, and, in fine,
Sick, wearied out with contrarieties,
Yielded up moral questions in despair.
(10:889–901)

In itself reason is a formal capacity for drawing inferences
and testing for consistency; it tells us how to go on with the alle-
giances we have, but it cannot itself take the place of belong-
ing, of identifying with an ongoing way of life, as the source of
our moral substance. From this it does not follow that our
moral commitments must therefore count as "irrational," or
that it is merely "relative" which ones we affirm. Such views
continue to suppose that morality, to be rational, must issue
from reason as such and that the basis of our moral reflection
should lie outside any given way of life. Exactly these assump-
tions, however, are what a Romantic such as Herder means to
reject. His point is rather that we must see our reason as a fac-
ulty that we exercise within the terms of the way of life to
which we belong, examining the merits of some of our prac-
tices in the light always of the deeper commitments to which
we hold fast.

Indeed, it is precisely by virtue of their wish to maintain a
connection between reason and morality that Romantic
thinkers such as Herder argued that we cannot understand our
deepest moral convictions as the objects of autonomous choice.
To have established, against Kant, that these convictions cannot

be drawn from reason alone rules out one way they could be viewed as commitments that one autonomously chooses. But that, of course, is not the only way. Autonomous choice might also be conceived as pure, groundless decision, without appeal to reason, a leap of faith. There were certainly Romantic thinkers who moved in this direction. F. H. Jacobi was one (though for this and other reasons he was poorly thought of by many of the greatest Romantics), and he proved an important model later for Kierkegaard in his *Concluding Unscientific Postscript*. But such is not the line of Romantic thought that interests me here, or that represents, as I believe, the fruitful strand in our Romantic legacy. Our attention ought rather to fix on those thinkers, like Herder, who drew from the moral vacuity of "pure reason" a different lesson—namely, the need to rethink what the idea of reason can mean. Their conclusion was that reason has been wrongly conceived when made the antithesis of community. To view our deepest convictions as the expression of our belonging is not a surrender of critical reflection, but a recognition of its sustaining basis.

In the Romantic period, this new conception of reason receives its most profound expression in the philosophy of Hegel. Far too complex a thinker to count as simply a Romantic (and often brutally critical of his Romantic contemporaries), Hegel nonetheless placed at the very heart of his thought the theme that reflection and belonging, reason and history, are not like water and oil, but weave together the very fabric of human

experience, each inseparable from the other. From this convic-
tion came his notion of a "phenomenology of the mind," that
is, the idea that the human spirit, even at its most revolutionary
and "world-historical," makes its advances not by rising to a
standpoint outside a given way of life but only by thinking
within it, attending to its internal contradictions and failed
aspirations.[11] Hegel's philosophy, taken as a whole, is doubtless
a grandiose and implausible construction. But if we strip from
it his confidence that History harbors an inner logic, geared
toward inevitable progress, then it shows itself to be the very
paradigm of the new conception of reason that the Romantics
introduced. It has been an inspiration to all those thinkers ever
since, in movements as otherwise diverse as American pragma-
tism and the Frankfurt School, who have sought to work out a
less metaphysical, more social conception of reason.

In important ways the Enlightenment was itself antimeta-
physical in spirit, as opposed to the speculative misuse of rea-
son as it was to religious obscurantism. But in the domain of
morality and politics, it appealed all too often (Kant is the most
dramatic, but not the only, example) to an obscurantist notion
of reason. Strange as this may sound to those who associate
Romanticism with reaction and unreason, the Romantic philos-
ophy of belonging represents a further step in intellectual clar-
ity, shedding light where the Enlightenment itself left darkness.
Far from its being inherently hostile to any particular concep-

[11] G. W. F. Hegel, *Die Phänomenologie des Geistes* (1807).

tion of duty or political life, its very essence was that no formal notion—be it reason or community—can by itself determine substantive positions. Where we can stand depends on the resources that our way of life provides.[12]

Community and Nation

Given this crescendo of approval, one may well wonder why I remarked, at the beginning of this chapter, that my discussion of the Romantic theme of community would be qualified in its enthusiasm. But now indeed I come to the rub. So far, I have been purposely vague about the precise contours of the "way of life" to which our moral life must remain connected. This was as it should be, since the aim was to establish a philosophical point. Some of the Romantics, however, showed a pronounced propensity to apply their general insight in a particular and unfortunate way. Especially among the German Romantics—from Herder through the Jena circle of the 1790s to Hegel, the *nation* was usually taken to be the decisive form of moral community. "National character," "the spirit of the people" (*Volksgeist*), "the organic state"—these are terms we are not wrong to associate with Romantic political thought, though as I have just suggested, they make up but one particular, and not inevitable, application of the more general recognition of the moral importance of belonging.

What these Romantics, and the nationalism that their writings inspired, meant by *nation* was, of course, an independent,

[12] I explore this line of thought further in *The Morals of Modernity*.

politically constituted community, or (perhaps more frequently) a community that may not yet, but ought to, enjoy this sort of sovereignty. Today it is a common view in Western intellectual circles that nationalism has been a pernicious thing, its reemergence after the end of the Cold War something to be dreaded. I will myself be drawing out the fatal simplifications by which these Romantics too often cast their praise of belonging into a nationalist mold, giving a bad name to their real insights about the moral life. But before doing that, I want to point out that the present antinationalist consensus itself makes things too easy. The institutions of liberal democracy that we may so prize today were themselves, in the West, achievable only through the centralizing forces that formed the modern state and this state-building necessarily took place with a certain nationalist spirit. It is anachronistic to view nationalism, and its Romantic sources, only in the light of the horrors it has produced.

But, that said, I do believe that those Romantics who *identified* moral community with the nation went terribly wrong. There are two reciprocal simplifications that their brand of communitarianism involved. For moral community can prove to be *smaller* and also *larger* in scale than the nation.

The first simplification is evident in those statements by which Herder has justly come to be regarded as the father of modern nationalism. "Der natürlichste Staat," he once announced, "ist *ein* Volk, mit *einem* Nationalcharakter" [The most

natural political state is *one* people, with *one* national character],
and so he scorned "die wilde Vermischung der Menschen-
gattungen und Nationen unter *einem* Zepter" [the wild mixing
of human types and nations under *one* scepter] as a mere
"Staatsmaschinerie," or "political machine."[13] This organic
image of the state is clearly ill-suited to acknowledge anything
of value in what is nonetheless, and was already so in Herder's
day, one of the most salient features of modern political life. It
is that the members of a modern state typically espouse a vari-
ety of religious persuasions, follow the divergent folkways of
different cultural traditions, and in general identify with many
opposing visions of the good life. The communities of belief
and practice that give their life substance often figure therefore
at a smaller scale than the nation-state as a whole (and at the
same time can cut across national boundaries). This does not
mean that such people may not also share a way of life that
unites them at the level of their political association. But it does
show how high talk of "one people with one national character"
is bound to miss the significance of those allegiances that divide
people within a given political community. The cost of pretend-
ing such differences do not exist, instead of devising principles
of political association to unite people in spite of them, is evi-
dent. The danger appears vividly in those fatal formulas with
which Hegel, for example, expressed his own identification of
moral community with the state: "The state is the actuality of

[13] Herder, *Ideen zur Philosophie der Geschichte der Menschheit* (1784), book 9, sec. 4.

the ethical Idea. . . . We must therefore venerate the state as something like a God on earth" [*ein Irdisch-Göttliches*].[14]

It would not be wise to suppose that the moral importance of subnational communities is a passing phenomenon, destined to disappear once political boundaries are finally made to coincide with religious-cultural identities. On the contrary, the proliferation of divergent ideas of the good life, and of the communities embodying them, is the norm rather than the exception. Reasonable disagreement about the meaning of life is what we should expect: the more we talk about such things, the more we are likely to differ, even with ourselves. This has been one of the cardinal experiences of modern life, ever since Montaigne observed,

> Jamais deux hommes ne jugèrent pareillement de même chose, et est impossible de voir deux opinions semblables exactement, non seulement en divers hommes, mais en même homme à diverses heures.[15]

> [Never have two men judged alike of the same thing, and it is impossible to find two opinions exactly similar, not only in different men but in the same man at different times.]

No appreciation of the value of community should be without a recognition of this truth. And as a matter of fact, some of the

[14] G. W. F. Hegel, *Grundlinien der Philosophie des Rechts* (1821; reprint, Frankfurt: Suhrkamp, 1970), nos. 257, 272 Zusatz.

[15] Montaigne, "De l'expérience," *Essais*, book 3, essay 13, in *Oeuvres complètes*, ed. Maurice Rat (Paris: Gallimard, 1962), p. 1044.

Romantics saw this clearly and championed a complex sense of belonging that gives an integral role to individuality. Witness what Friedrich Schleiermacher had to say at the beginning of his speeches *On Religion* of 1799. We must avoid, he wrote, the two extremes of self-magnification and self-surrender, and so it is fortunate that there are always those who

> are imbued in a fruitful manner with both impulses...and are rec-
> oncilers of things that otherwise would be eternally divided...
> who unite those opposing activities, by imprinting in their lives a
> characteristic form upon just that common nature of spirit.[16]

The interplay between individuality and belonging is a theme that Schleiermacher pursued indeed through many domains. It lies at the heart of the "hermeneutics" that he so famously developed, for this was a theory of interpretation according to which the understanding of any meaningful expression (from literary texts to everyday speech) consists in seeing it as the individual articulation of a shared language and form of life. And the same idea recurs in his ethics, where he was concerned to present the moral life as the practice of judgment and imagination in the observance of common principles.[17]

[16] Friedrich Schleiermacher, *On Religion: Speeches to Its Cultured Despisers*, trans. J. Oman (New York: Harper & Row, 1958), p. 6.

[17] Friedrich Schleiermacher, *Hermeneutik und Kritik*, ed. M. Frank (1838; reprint, Frankfurt: Suhrkamp, 1977), and *Grundlinien einer Kritik der bisherigen Sittenlehre* [Foundations of a Critique of Ethics Up to Now] (1803).

The second simplification in the equation of community and nation is that it ignores the extent to which moral community can transcend, not accidentally but by intention, the sphere of national differences. I am thinking especially of those modern institutions and traditions—from the practice of religious toleration and the cultivation of individual conscience to the impersonality of the free market—that variously conspire to nourish the conviction that all human beings, whatever their national allegiance, are worthy of moral respect, by virtue of their very humanity. Our way of life, in many of its deepest dimensions, is unboundedly inclusivist by nature. Again, this fact was not unavailable to Romantic thinkers, though Joseph de Maistre, for one, pretended not to know it when he famously exclaimed,

> J'ai vu, dans ma vie, des Français, des Italiens, des Russes, etc.; je sais même, grâces à Montesquieu, *qu'on peut être Persan*: mais quant à *l'homme*, je déclare ne l'avoir rencontré de ma vie; s'il existe, c'est bien à mon insu.[18]

> [I have seen in my life Frenchmen, Italians, Russians, etc.; I even know, thanks to Montesquieu, that *one can be a Persian*: but as for *man*, I declare that I have never met him in my life; if he exists, it is unbeknownst to me.]

Hegel's example shows, however, that a Romantic appreci-

[18] Joseph de Maistre, *Considérations sur la France* [1797], in *Ecrits sur la Révolution*, ed. Jean-Louis Darcel (Paris: Presses Universitaires de France, 1989), sec. 6, p. 145.

ation for belonging did not have to be so blind to the reality of modern society. His account of what he called modern *Sittlichkeit*, or "ethical life," aimed precisely to explain how a universalist conception of morality draws its substance from a specific, peculiarly modern form of life that has become our own.[19] This form of life expresses an ethic of respect for humanity, not just at the level of enunciated principles but also in such characteristic practices as religious toleration and *le doux commerce*—making religion a matter of individual conscience and channeling individual aggression away from the cult of martial valor, with its accentuation of national differences, and toward the more ecumenical struggles of economic competition. Hegel's anti-Kantian argument was that a universalist ethic does not derive from reason as such and then lead us to discern the value in this way of life. Such a derivation is impossible, "reason as such" being indeed but a formal capacity. Instead, only by virtue of belonging to this way of life do we reason in ethics as we do and judge social practices in the name of universalist principles. Hegel's vision of moral universalism as a form of life is one of the great and powerful ideas of social theory. All the more shame, therefore, that he too tried nonetheless to squeeze, Procrustean fashion, the value of moral community into the frame of the nation-state.

In sum, Romantic nationalism put a good insight to bad use

[19] Hegel, *Grundlinien der Philosophie des Rechts*, part 3, "Die Sittlichkeit."

by failing to recognize that our sense of belonging quite properly takes root not only or even primarily in our political life but also in communities of belief and practice whose scope is less than or extends beyond that of the nation. This mistake explains a striking deficiency of much of Romantic political thought—its inability to admit that political association has a *specific* function, essential but delimited. All too often the Romantics saw the state as either *everything* or *nothing*. Sometimes it was thought that the state, as the fundamental expression of moral community, should be omnipresent in social life, as when Novalis exclaimed, "A great failing of our states is that we see the state too seldom. The state should be visible everywhere. Could not insignia and uniforms be introduced throughout?"[20] This statement comes from a book, *Glauben und Liebe*, which Novalis wrote for the new Prussian king, Friedrich Wilhelm III, flattering him with the argument that political stability cannot rest on anything so unstable as interest or reason, but only on the all-consuming bonds of "faith and love" invested in a charismatic sovereign. Sensibly enough, Friedrich Wilhelm declined Novalis's overtures, replying, "More is being demanded of a king than he can possibly perform."

But at other times, if Romantic thought deemed the state

[20] Novalis, *Glauben und Liebe* [1798], sec. 19, in *Werke*, 2:295: "Ein großer Fehler unseres Staates ist es, daß man den Staat zuwenig sieht. Überall sollte der Staat sichtbar . . . seyn. Ließen sich nicht Abzeichen und Uniformen durchaus einführen?"

unable to embody all our deepest aspirations, it simply dismissed it and wished it out of existence. Thus, the anonymous author (whether it was Hölderlin, Hegel, or Schelling is disputed) of the manuscript called "Das älteste Systemprogram des deutschen Idealismus" (1797) proclaimed, "We must move beyond the State. For every state treats free men as mechanical clockwork."[21]

Between these two extremes, there drops out any notion of the special kind of moral community that the liberal-democratic tradition has seen in political association. Such a community is one that is divided by alternative visions of the good life but united by a common commitment to the principle of equal respect for settling its differences and still sharing enough by way of language, geography, or a common history to see itself as a people distinct from others. We will not therefore find, at least among the German Romantics I have mentioned, much of a direct contribution to the theory of liberal democracy. Their identification of moral community and nation stands in the way. This mistake of theirs was, however, doubly unfortunate—not just because it diminished their own vision but also because it has too often kept us from appreciating their more

[21] The best edition of and commentary on this manuscript are to be found in Christoph Jamme and Helmut Schneider, eds., *Mythologie der Vernunft: Hegels "ältestes Systemprogamm" des deutschen Idealismus* [Mythology of Reason: Hegel's "Oldest System-Program" of German Idealism] (Frankfurt: Suhrkamp, 1984). The passage quoted is on pp. 11–12: "Wir müssen also auch über den Staat hinaus!—Denn jeder Staat muß freie Menschen als mechanisches Räderwerk behandeln."

general insight into the value of belonging, and from incorporating it into our own self-understanding.

Tradition and Innovation

As I observed before, we miss the originality of the Romantic theme of belonging if we suppose it refers simply to the influence that common forms of life actually have on the individual mind. At stake is instead the sort of self-understanding that *ought* to be ours, namely, one in which we view our deepest commitments not as the objects of autonomous choice but rather as the expression of our belonging to a given form of life. Such a self-understanding is a normative one, precisely because it depends essentially on an idea of reason, indeed, on a new one. Instead of requiring us to stand back critically from our way of life as a whole, as though its ultimate aim were to view the world *sub specie aeternitatis*, reason ought really to be seen as directed toward how we are to go on within the terms of this way of life.

I have scarcely been able to disguise my own conviction that this Romantic conception of reason forms a positive advance over the moral rationalism of the Enlightenment. But I want to conclude this chapter by observing that, besides being on the right track, this idea of reason also represents an *innovation*. Nothing would be further from the mark than to suppose that the Romantic theme of belonging involves the recovery of a truth that Enlightenment thought had lost. The idea that reason moves us, by its very nature, to seek to undo the weight of his-

torical circumstance, to stand back from our way of life and rethink our commitments on the basis of reason alone, goes back well before the Enlightenment. It forms one of the age-old metaphysical aspirations, perhaps as old as philosophy itself, and certainly not restricted to philosophy alone, drawing as it does on religious motives as well.

To have rejected this outlook, as did Herder and Hegel, among other Romantics, was hardly then to beat the drum for a return to older, pre-Enlightenment forms of thinking. On the contrary, the existing ways of life, the traditions of moral belief and practice that they saw as constitutive of our self-understanding, were themselves seldom tradition-minded but had often sought their legitimacy in a direct relation to some transcendent source such as the voice of reason or God's will. This fact might be called *the paradox of traditionalism*. To appeal to our sense of belonging, even in the name of a new conception of reason, is not to enjoy any simple sort of continuity with the forms of life with which we thereby identify.

The "paradox" need not lead to self-contradiction—so long as we acknowledge the element of innovation that this form of thought involves. But it cannot be said that later thinkers who have taken up the Romantic theme of tradition have always shown the necessary self-awareness. A case in point is the contemporary philosopher Alasdair MacIntyre, who has become the best-known figure in this line of thought. MacIntyre has had insightful things to say about the indispensable role of tradition

in moral thinking. But he has also rashly trumpeted his moral philosophy as antimodern because it is anti-Enlightenment, supposing that he is accomplishing a return to premodern, Aristotelian, or Thomistic modes of thought. "What the Enlightenment made us for the most part blind to," MacIntyre writes, "and what we now need to *recover* is . . . a conception of rational enquiry as embodied in a tradition, a conception according to which the standards of rational justification themselves emerge from and are part of a history."[22]

But in reality such an outlook is very far from "recovering" a pre-Enlightenment form of thought that had gotten lost. Nothing could be more absent from premodern thought than MacIntyre's traditionalism, his sense of historical context, and his view that reason must welcome being at home amid historical contingency, instead of seeking to transcend it. The fact is so obvious that not even MacIntyre can deny it. "The major moral and metaphysical thinkers of the ancient, medieval, and even the early modern world," he goes on to concede, were not "themselves concerned with, let alone provide[d] an adequate account of, the nature of such traditions."[23] True, but why then speak, as MacIntyre does, of *recovering* a premodern idea of reason? MacIntyre's traditionalism makes him a modern, even if in spite of himself.

[22] Alasdair MacIntyre, *Whose Justice? Which Rationality?* (South Bend, Ind.: University of Notre Dame Press, 1988), p. 7 (emphasis added).
[23] MacIntyre, *Whose Justice?*, p. 8.

The German Romantics, by contrast, generally avoided tying themselves up in these sorts of knots. They freely admitted, indeed embraced, the novelty of their respect for tradition and belonging. Precisely what I have called the "paradox of traditionalism" is what Novalis, for example, brings out in his famous aphorism,

Es sind viele antirevolutionäre Bücher für die Revolution geschrieben worden. Burke hat aber ein revolutionäres Buch gegen die Revolution geschrieben.[24]

[Many antirevolutionary books have been written in favor of the Revolution. Burke, however, has written a revolutionary book against the Revolution.]

Moreover, an awareness of their innovation also comes out implicitly in a characteristic way that the Romantics had of articulating their sense of belonging. They insisted that a community to which we affirm our belonging on the basis of this truly new form of self-understanding is not a community that is *simply given*. It must be a community that we also at the same time reconceive, a community no less *imagined* than real. So Friedrich Schlegel wrote in his *Lyceumsfragmente* of 1797 (with his regrettable fixation on simply national community),

<hr>

[24] Novalis, *Blüthenstaub* [1798], sec. 104, in *Werke*, 2:279.

An dem Urbilde der Deutschheit, welches einige grosse vater-
ländische Erfinder aufgestellt haben, lässt sich nichts tadeln als
die falsche Stellung. Diese Deutschheit liegt nicht hinter uns,
sondern vor uns.[25]

[In the archetype of Germanness, which some great patriotic
inventors have erected, I have nothing to criticize save its
wrong point of view. This Germanness lies not behind us, but
ahead of us.]

Recent writers on nationalism, such as Benedict Anderson,
have rightly underscored the fact that modern nations do not
really reach back to the mists of time, much as they like to
describe themselves thus. They have rather the character of
"imagined communities" (that is the title of Anderson's
book),[26] which can indeed be fashioned only on the basis of con-
ditions peculiar to modern society, such as economic homoge-
nization and universal literacy. However timely Anderson's
argument may be, however well aimed against the more
unthinking sectaries of modern nationalism, its thesis is one that
in essence Romantic thinkers such as Schlegel already accepted.

Benedict Anderson also correctly faults other current writ-
ers on nationalism, such as Ernest Gellner, for thinking that if

[25] Friedrich Schlegel, *Schriften zur Literatur*, ed. Wolfdieter Rasch (Munich: Hanser, 1970),
p. 11.
[26] Benedict Anderson, *Imagined Communities*, rev. ed. (London: Verso, 1991).

nations have been imagined, they have simply been "invented" out of whole cloth, unconstrained by existing ways of life and expressing only "false consciousness."[27] But in this, too, the Romantics were there before him. As I explained in chapter 1, the Romantic imagination in general aims to be creative and responsive at once, attuned to experience as it also enriches it. So it may well be true that the Romantic sense of belonging is inescapably an act of the imagination, transfiguring as it does its favored traditions in a traditionalist spirit that they did not themselves have before. But this does not mean that such forms of life do not really exist. And where they do exist and move our being, our imaginative identification with them can count as an expression of reason, as the Romantics have taught us to reconceive it. To my mind, these insights are too philosophically rich to lose when we rightly reject the nationalistic blinders that have so often narrowed the Romantic vision of society.

[27] Ernest Gellner, *Thought and Change* (London: Weidenfeld & Nicholson, 1964), p. 169, and *Nations and Nationalism* (Ithaca: Cornell University Press, 1983), p. 124.

IRONY AND AUTHENTICITY

In the previous chapter I tried to take a measured view of probably the most troublesome strand in our Romantic inheritance—the theme of community. The value that the Romantics found in belonging involves, I argued, a fundamental reorientation of thought, one that no longer supposes that reason aims essentially at rising above historical circumstance but sees it instead as determining how to go on within the way of life that is ours. This new conception of reason expresses a genuine philosophical insight. But it is not only the novelty of it that has stood in the way of a proper appreciation. The greatest obstacle has been the principal way the Romantics themselves made

their insight concrete—namely, by identifying moral community with the nation. There was nothing inevitable about so dangerous a narrowing of focus. But we cannot make this part of the Romantic legacy our own without an acute awareness of the pernicious forms of thought it has inspired.

The value of community forms one central element in our Romantic inheritance. It also stands, however, in some tension with another Romantic concern of equal consequence. This is the heightened sense of individuality—of what it is to be an individual, distinct from one's community and true to oneself—that we inescapably associate with Romanticism. I will now pursue the Romantic conception of individuality in its two most distinctive forms, *irony* and *authenticity*. This discussion will provide a balance to the focus on community that I presented in chapter 2.

That belonging, however important a theme, cannot be the "essence" of Romanticism probably needs no extended argument. For we are doubtless all familiar with a contrary Romantic conviction, expressed often by the very same writers, that our deepest aspirations cannot ultimately be satisfied by any specific, circumscribed form of life. No less eloquent a voice for the moral importance of belonging than Wordsworth, for example, could also exclaim in the *Prelude*:

Our destiny, our nature, and our home
Is with infinitude, and only there;

With hope it is, hope that can never die,
Effort, and expectation, and desire,
And something evermore about to be.
(6:538–42 [1805])

(As is often the case with Wordsworth, this philosophical dec-
laration is occasioned by reflection on an ordinary sort of expe-
rience: he is remembering the time he walked through the Alps
in excited anticipation of his arrival at their highest point, only
to discover that he had already passed it some miles back.)

To say with Wordsworth that our home is with infinitude is
to imply that we cannot finally feel at home in the world, or in
any given way of life. This outlook forms an unmistakable part
of our Romantic inheritance. Chateaubriand called it *le vague
des passions*, the felt inadequacy of any particular object of
desire, which he saw agitating his age. "Plus les peuples avan-
cent en civilisation," he wrote,

plus cet état du *vague* des passions augmente. . . . Le grand
nombre d'exemples qu'on a sous les yeux, la multitude de
livres qui traitent de l'homme et de ses sentiments, rendent
habile sans expérience. . . . On habite avec un coeur plein, un
monde vide; et, sans avoir usé de rien, on est désabusé de tout.[1]

[1] François-René Chateaubriand, *Génie du christianisme* (1802), 2.3.9. See also his *Mémoires
d'outre-tombe* (Paris: Gallimard, 1951), 1:462.

[The more people advance in civilization, the more this condition of the *vagueness* of the passions increases. . . . The great number of examples one has before one's eyes, the multitude of books that deal with man and his sentiments, make one clever without experience. . . . One inhabits with a full heart an empty world; and, without making use of anything, one is disabused of all.]

Or as Benjamin Constant (in so many regards Chateaubriand's leading intellectual adversary in France at this time) also observed,

Les anciens étaient dans toute la jeunesse de la vie morale; nous traînons toujours après nous je ne sais quelle arrière-pensée qui naît de l'expérience, et qui défait l'enthousiasme.[2]

[The ancients were completely in the youth of the moral life; we always drag behind us some mental reservation or other which comes from experience and which saps enthusiasm.]

The discrepancy in their otherwise similar remarks is to Constant's credit. He saw better than Chateaubriand did that this spiritual restlessness stems from experience rather than from the lack of it. For, as indeed they both agreed, it is aroused

[2] Benjamin Constant, *De l'esprit de conquête et de l'usurpation* [On the Spirit of Conquest and on Usurpation] (1814), part 2, sec. 6.

above all by the sense of being a latecomer, surrounded by a cultural tradition whose very richness defeats simple allegiances.

This Romantic sensibility forms also a part of our own. Convinced though we may be that we follow reason in drawing our moral bearings from the way of life that is ours, we cannot honestly profess a wholehearted identification with any inherited form of life. Something deeper than reason always urges us, even as we feel we belong, to stand back, if only just a bit.

Both Wordsworth and Chateaubriand, in the passages cited, claim it is the imagination that moves us forever beyond: we cannot help but always wonder how else things might be.[3] Though this is not really the whole answer, it is not surprising that they were drawn to such a diagnosis. The Romantics, I have argued, made the imagination the central organizing principle of the mind because they were convinced that we respond to the world only through forms of understanding that we have ourselves created, necessarily enriching our experience as we express it. It is in the imaginative nature of the mind to go beyond what is given. This is true, even when we see ourselves as part of a larger whole, and particularly when (as some of the Romantics urged) we come to recognize our ties of time and place not as an obstacle to the life of reason but as its very substance, for then the communities to which we belong are also, as I have explained, ones that we reconceive.

[3] Wordsworth, *The Prelude* (1805), 6:525; Chateaubriand, *Génie du christianisme* 2.3.9 (first paragraph).

Still, the question remains, what propels the mind to *keep* going beyond, to feel never at rest in any of its achievements, to stand back even from those fundamental moral commitments that we cannot imagine ever giving up? That is a more difficult question. I am tempted to reply, however awkwardly, that it is the human spirit itself, and I will try to say something about it shortly. But giving the phenomenon a name matters less than recognizing its existence. The disquiet of never feeling fully at home figures, as much as the sense of belonging, among the central strands of the Romantic legacy and can only strike a resonant chord in our own self-understanding.

It is all the more important, therefore, that we grasp just what this Romantic sense of the infinite involves. For here, too, we must battle established preconceptions that keep us from making the most of our Romantic inheritance. The three most formidable of these obstacles can be formulated thus: First, does being nowhere at home in the world amount simply to Romantic *Weltschmerz*, a pathological condition having no general relevance to the human condition? Second, is the sense that "our home is with infinitude" but an example of the "spilt religion" that T. E. Hulme condemned[4] (or of that "natural supernaturalism" which, reversing signs, a modern critic such as M. H. Abrams extols) as the arrogation to man of perfections that used to pertain to God alone? And finally, does the feeling of spiritual homelessness signal merely an inability to

[4] T. E. Hulme, *Speculations*, p. 118.

take things seriously, a craven retreat from true commitment? These are the key objections we must answer if we are to reclaim a central Romantic theme and to make better sense of our modern idea of individuality. For at its most powerful, the Romantic disquiet with everything nailed down and finite gives rise to that attitude so important to the modern subject that is irony.

The Forms of Romantic Homelessness

An exceptionally striking example of the conflict between the two Romantic ideas of infinity and community is that greatest of all philosophical hatreds, the loathing that Arthur Schopenhauer felt for Hegel. Windbag, charlatan, intellectual Caliban—that is some of the abuse Schopenhauer hurled at Hegel after his death in 1831. In part, Schopenhauer's attitude sprang from the resentment that younger faculty are bound to feel for their senior, more established colleagues: in the early 1820s as a fresh *Privatdozent*, he had scheduled his classes for the same hour as Professor Hegel's, and nobody attended. But Schopenhauer's hatred also had deeper, intellectual roots.

At stake was Schopenhauer's utter opposition to the Romantic praise of belonging, to which it was Hegel who gave supreme philosophical expression. In Hegel's view, philosophy aims to reconcile us to the world, to see (as he wrote in the preface to his *Rechtsphilosophie* [1821]) "the rose in the cross of the

present."[5] For Schopenhauer, by contrast, philosophy is essentially the discipline of homelessness. "Life is such a sorry affair," he once remarked, "I have resolved to spend it by reflecting upon it."[6]

We would misunderstand the nature of Schopenhauer's outlook if we supposed it came from cleaving to that older view of history-transcending reason that Romantics such as Hegel had sought to unseat. On the contrary, Schopenhauer had a rather this-worldly conception of reason: seeking out the relations of dependence among things (in accord with the four forms of the Principle of Sufficient Reason—cause/effect, ground/belief, premise/conclusion, motive/action), reason has nonetheless no natural drive toward prime movers or first principles. It just goes on and on within the limits of experience, beginning in medias res and never coming to an end. But Schopenhauer was convinced that a deeper drive than reason propels us beyond the finite, ruining any feeling of being at home in the world. That impetus is profound, inconsolable disappointment. When we face without illusion the inevitable disproportion between our efforts and our achievements, we will conclude, he believed, that life is at bottom but blind will, and we will seek

[5] "Die Vernunft als die Rose im Kreuze der Gegenwart zu erkennen und damit dieser sich zu erfreuen, diese vernünftige Einsicht ist die *Versöhnung*, welche die Philosophie gewährt" [To recognize reason as the rose in the cross of the present and thereby to enjoy the present is the *reconciliation* which philosophy affords] (G. W. F. Hegel, *Grundlinien der Philosophie des Rechts* (1821; reprint, Frankfurt: Suhrkamp, 1970), pp. 26–27).

[6] Arthur Schopenhauer, *Gespräche*, ed. A. Hübscher (Stuttgart: Frommann-Holzboog, 1971), p. 22.

salvation from the world through ascetic self-denial. We will aim (as Schopenhauer wrote in his diary in 1813) at that "better consciousness . . . where neither personality nor causality, neither subject nor object, exists anymore."[7]

This bleak view of the world's possibilities was the most extreme form that the Romantic theme of infinity and homelessness could take. Other Romantics certainly gave this theme the same direction that Schopenhauer did. Think, for example, of the conclusion of Giacomo Leopardi's poem, *L'infinito* (1819). He begins by evoking the things in this world that he has held so dear—

> Sempre caro mi fu quest'ermo colle,
> E questa siepe, che da tanta parte
> Dell'ultimo orizzonte il guardo esclude.
> (1–3)

> [This lonely hill was always dear to me,
> And this hedgerow, which hides so much
> Of the ultimate horizon from my view.]

But then he lets these ties dissolve in his imagined absorption into the infinite horizon that lies beyond, so that "il naufragar m'è dolce in questo mare" [shipwreck is sweet to me in this sea].

[7] Arthur Schopenhauer, *Der handschriftliche Nachlaß*, ed. A. Hübscher (Munich: Deutscher Taschenbuch Verlag, 1985), 1:42.

Yet world-weariness was not, as we shall see, essential to the Romantic feeling of not being at home in the world. And in fact, Schopenhauer's pessimism is so sweeping, so all-encompassing, that it falls into incoherence. If life reduces to the futility of the will, how can life also contain the resolve to push beyond it? How can we become will-less, if (as Schopenhauer's *World As Will and Representation* [1819] asserts) the will is the ultimate nature of everything? These inconsistencies might make us wonder whether the idea of spiritual homelessness cannot find some value in the ties of time and place, even though it must deem them inadequate.

This more nuanced sense of the infinite is what we find in other Romantic writers. Novalis is one such example. The first aphorism of his *Blüthenstaub* (1798) invokes the idea of an unending quest in a way that may sound like Schopenhauer's dismissive disappointment with the world. "Wir suchen überall das Unbedingte," he wrote, "und finden immer nur Dinge"[8] [We search everywhere for the Unconditioned, and always find only things—there is an untranslatable etymological contrast in the German between "the Unconditioned" and "things"]. But Novalis's point is really rather more complex. To see why, recall from the first chapter that for Novalis, as for the other great Romantics, the imagination does not aim at transcending the world, but rather shapes our very sense of reality. If, as Wordsworth and Chateaubriand—and Novalis too—were

[8] Novalis, *Werke*, 2:227.

persuaded, the imagination is nonetheless driven always to project beyond present understandings, we may indeed feel unable to identify completely with anything in the world, with any of our existing views. But when we thus conclude that our home is "with infinitude, and only there," the impulse by which we are drawn is that of conceiving ever new ways that the world itself could be. Such a sense of the infinite cannot then be Schopenhauer's longing to get beyond life. It consists rather in a certain way of dealing with the things of the world.

This is what Novalis remarks later on in the *Blüthenstaub*:

Alle Zufälle unseres Lebens sind Materialien, aus denen wir machen können, was wir wollen. . . . Jede Bekanntschaft, jeder Vorfall wäre für den durchaus Geistigen—erstes Glied einer unendlichen Reihe—Anfang eines unendlichen Romans.[9]

[All chance occurrences in life are materials out of which we can make what we want. . . . Every acquaintance, every incident can be for the really thinking person the first member of an infinite series, the beginning of an infinite novel.]

Novalis's view is that the things of this world are essential to our intimations of the infinite. Though seeking the infinite we find only the finite, we cannot keep looking for what eludes us, except in a quest that is fueled by the tangible things we meet with.

[9] Novalis, *Blüthenstaub*, sec. 66, in ibid., 2:253.

Irony

Novalis's more complex conception of feeling nowhere at home in the world deserves closer analysis. What essentially distinguishes his version from Schopenhauer's is that it does not picture this restlessness as a *single-minded* push to get beyond the world. It regards the feeling of disquiet as instead a state of *being of two minds*. We hold back from identifying completely with what we nonetheless affirm. The proper term for such an attitude is naturally *irony*. Novalis wrote his *Blüthenstaub* as a member of the Jena circle of the 1790s, which invoked irony as its master concept and made Romanticism, in the eyes of many, synonymous with the phenomenon.

The Jena circle's principal theoretician of irony was Friedrich Schlegel, of course. His focus lay primarily with the function of irony in works of art, particularly in modern times. But let me remind you again of the fundamental point I have been concerned to establish throughout: The poetic imagination, especially as Schlegel and the other Jena Romantics understood it, is not a "purely aesthetic" faculty. It does not aim to rewrite the world in the language of autonomous art. The imagination plays instead the central role in structuring our very sense of reality, creating the forms of understanding by which we articulate our experience. The same is true, the Romantics believed, of the imagination's characteristic tropes, such as irony. No doubt they may enjoy in works of art a pecu-

liarly heightened expression. But their force then lies precisely in impressing on us their workings in life itself.

So when Schlegel, in one of his most famous *Athen-äumsfragmente* (1798), couples irony with a sense of the fragmentary—

> Viele Werke der Alten sind Fragmente geworden. Viele Werke der Neueren sind es gleich bei der Entstehung.[10]

> [Many works of the ancients have come down as fragments. Many works of the moderns are fragments from the very beginning.]

—he is referring not just to modern works of art but also to a modern cast of mind. Ironical moderns wish their views and deeds to be understood as *fragments*, because their commitments can never express *wholly* what they are themselves. Committed though they be, their thought is always elsewhere as well. Of course, fixing the content of this "elsewhere," nailing down the arrière-pensée, is likely to meet with the same fate, yielding but a fragmentary identification. Irony, at its most persistent, beckons then toward the infinite, suggesting more than can ever be made perfectly clear. As Novalis wrote, manifestly as much about life itself as about art, "A poem must

[10] Friedrich Schlegel, *Schriften zur Literatur*, ed. Wolfdieter Rasch (Munich: Hanser, 1970), p. 27.

be completely *inexhaustible*, like a human being, or a good aphorism."[11] We would not have our sense of the indefinable individuality of human lives if we did not understand ourselves as inevitably ironical beings.

The most significant feature of Romantic irony is that it expresses this sense of individuality, and it does so precisely because it ties itself to the world at the same time as it draws back. Matters are otherwise with Schopenhauer's different version of what it is not to feel at home. The world-weariness that longs simply to get beyond the world carries a wish to overcome the self as well. Self-extinction is what Schopenhauer himself elevated to the supreme goal, and that is what Leopardi, too, embraced at the end of his *L'infinito*:

> Così tra questa
> Immensità s'annega il pensier mio:
> E il naufragar m'è dolce in questo mare.

> [Thus in this immensity my thought is drowned, and shipwreck is sweet to me in this sea.]

But in the case of irony, one can be drawn to the infinite, of which one finds every commitment or form of life falling short, only by reserving one's full assent and so underscoring one's distinctness. "Nous traînons toujours après nous je ne

[11] Novalis, *Werke*, 2:826.

sais quelle arrière-pensée," as Constant put the point, "qui défait l'enthousiasme"—and which reminds us of ourselves. The thought "That's of course not really *me*" is here a precondition for the sense of infinity.

Yet if the two-mindedness of irony makes it an expression of individuality, it also keeps this sense of self from swelling into a posture of sovereign, unlimited power. Ironic subjectivity, whatever its intimations of the infinite, is essentially finite subjectivity. Nothing could be more unjust than Hulme's charge that Romantic talk of the infinity of human desire is but spilt religion and the divinization of man. For irony beckons toward the infinite, toward what lies forever beyond, only by remaining also tied to the finite. We cannot be of two minds about our commitments if we are not indeed committed and take our stand in a determinate way, even as we hold back from placing ourselves there entirely.

By this point we have arrived at two important conclusions about Romantic homelessness, which refute some preconceived ways of dismissing it and which bear repeating. First, the feeling of being nowhere at home in the world, not fully belonging to any particular form of life, need not involve the peculiar funk of world-weariness. And, second, when in the spirit of irony this feeling does maintain its ties to the world, as it looks also toward the unlimited horizons beyond them, it marries a sense of infinity with an assertion of self, though it does so without making subjectivity itself the infinite. Our task

of clearing away misconceptions is not yet over, however. Perhaps the most serious objection of all confronts the form of Romantic homelessness that I have portrayed as having the real claim on our attention—namely, irony. The charge is that irony is mere frivolity, a self-indulgent lack of seriousness. The objection at its most dismissive appears already in one of the famous passages of Hegel's lectures on aesthetics.

That Hegel, the philosopher of belonging and reconciliation with the world, should dislike Romantic irony ought not to come, of course, as much of a surprise. What is startling is that he had absolutely nothing good to say about it. In general, Hegel is the anti-Mephistopheles, "der Geist, der *nie* verneint" [the Spirit that *never* denies].[12] He never entirely repudiates a contrary philosophical position; rather he incorporates it, transformed, into a subsidiary element of his own system. Romantic irony is one of the few exceptions to this Hegelian strategy. It must have touched a nerve.

Irony, Hegel sneered, is mere twaddle (*Schwatz*).[13] It mocks all that is good and true and holy, and means only to parade its geniuslike superiority to the "deceived, poor *borné* creatures" who take things seriously. If Schlegel's theory of irony fixes on art as its privileged site of expression, that is only because, Hegel famously announced, art itself is intellectually a "thing

[12] Cf. Goethe, *Faust* 1:1338.
[13] G. W. F. Hegel, *Vorlesungen über die Ästhetik* [Lectures on Aesthetics] (Frankfurt: Suhrkamp, 1970), 1:95.

of the past" for us moderns, who are able to express all truths without the sensuous images of art, in abstract and discursive prose.[14] Schlegel's irony looks particularly to art, he surmised, because it does not care a hoot about truth or reality.

In Hegel's critique of Romantic irony we find a first expression of that perennial, aestheticist misconception about the Romantic imagination that I have been attacking. Let us look directly, however, at the charge of frivolity. The first thing to note is that it rests on a pure mistake. Irony is not the absence of commitment. It is, on the contrary, impossible without it. Irony is not the single-minded flight from commitment. It is instead the state of being of two minds, committed and reserved at the same time. But, in addition, the fundamental question is, Who is really being serious? And who is being frivolous? Is it a mark of seriousness to be so committed to a belief or practice that we cannot stand back from it and imagine how it might not have been ours or, at the very least, look at it from the outside as a disinterested spectator might? Or is such total absorption just caring too little about our commitments to acknowledge that they are indeed commitments, ways in which we have pinned ourselves down, which thus can never fully express our very being? Can we seriously believe, as Hegel claimed he did, that we have seen our way to feeling fully at home in the world, or to being

[14] Hegel, *Vorlesungen über die Ästhetik*, p. 25.

wholly at rest, at least in our most fundamental commitments? Or is this only a show, a bit of posturing? Schlegel once remarked that irony is a matter of "der heiligste Ernst," the most holy seriousness.[15] It is difficult for me to think the mature mind could believe otherwise.

An appreciation of this part of our Romantic legacy need not force us to abandon that other strand, which is the discovery of the importance of community. As I have indicated, ironic two-mindedness depends on commitment. And so it has a place for a sense of belonging and for the recognition that our moral substance stems not from reason as such but from the form of life within which alone we can reflect critically about what to believe and do. Irony amounts simply to the awareness that such belonging can never be total and all-absorbing. In some cases, ironic distance may involve imagining how commitments, which we have so far no reason to question, might nonetheless be replaced by something different or better. But irony is not fundamentally an "epistemological" attitude, in which we entertain how beliefs might be revised. It expresses, instead, the essential nonidentity between the commitments we have and our ability to commit ourselves. Even our deepest commitments, such as our fundamental principles of right and wrong, which Herder and other champions of belonging have taught us rightly to regard as felt convictions rather than as objects of rational choice (or a leap of faith), are still commit-

[15] Friedrich Schlegel, "Über Goethes Meister" [1798], in *Schriften zur Literatur*, p. 266.

ments. That is, they would not be ours if we had not bound ourselves to them. To see this is to look at even these commitments ironically, from a sense of ourselves that lies outside them.

Irony, however, is but one of Romanticism's distinctive contributions to our modern notion of individuality. There is also a second, which occupies, as it were, the opposite pole. It is the idea of authenticity. To appreciate how these two forms of individuality differ, we must take note of a further feature of irony that I have not brought out before. Ironic two-mindedness is essentially an attitude of *reflection*. By this I do not mean that reflection must always prove ironical, for it may instead simply confirm our sense of where we stand. But it is also true that we cannot make a mental reservation with regard to our commitments except by reflecting upon them.

An important question, however, is whether individuality is inherently reflective. Though being an individual does not require breaking with the ways of the community, it does involve no longer fully identifying with them in some regard. Can we show our distinctness only by standing back reflectively and ironically from such an identification? The answer, I believe, is "No." The idea of authenticity expresses a very different and essentially nonreflective way of being an individual, unabsorbed by a sense of belonging. It, too, figures in our Romantic legacy. But to appropriate this part of our inheritance, we must overcome some very powerful misconceptions.

Authenticity

The passion for authenticity goes back before the appearance of the term itself; its roots lie in pre-Romantic thought, notably in that great precursor, Rousseau. Social life, so Rousseau believed, is ruled by a constant comparing of ourselves with other people: we follow the lead of others, wanting and believing what they do, or we seek to distinguish ourselves by devising ways of displaying our superiority. Either way, we are no longer ourselves. Rousseau's overriding goal was the recovery of an authentic sense of self, the retrieval of naturalness and spontaneity. In this he became the founding hero of one of the most important strands of Romantic thought and of an enduring element of our own notion of individuality.

For all its powerful hold on our self-conceptions, the ideal of authenticity has not gone unchallenged in modern thought. There have been worries, of course, about the adversarial relation to society that it fosters, and not just out of fear of anomie but also because the pursuit of this ideal can blind us to the real value that lies in a sense of belonging. This is the theme of Lionel Trilling's great book *Sincerity and Authenticity*.[16] As you would expect, I cannot but have some sympathy for this concern, though I would not, any more than Trilling would, use it as a pretext for rejecting the claims of authenticity. But I am more interested in a different sort of objection to the ideal—the

[16] Lionel Trilling, *Sincerity and Authenticity* (Cambridge, Mass.: Harvard University Press, 1972).

charge that being authentic, being ourselves, forms a fundamentally incoherent aspiration. There can be, it is argued, no such thing as an authentic self, no inner core of our being that is free from the effects of social comparison. In the words of René Girard, the most notable proponent of this position today, authenticity is "le mensonge romantique"—the lie of Romanticism.[17]

I must declare from the outset my considerable sympathy with Girard's standpoint as well, or more exactly with his view that there does not lie within us a real self, unshaped by social convention.[18] The question, however, is whether the notion of such a self is essential to the ideal of authenticity. No doubt, belief in an authentic self has often drawn, as Girard supposes, on the two assumptions that (1) this self is already part of us, though lost from sight (and recoverable only through long and arduous self-analysis), and (2) this innermost dimension of our being is one that escapes the influence of social convention. No doubt, too, such a conception of authenticity—of what it is to be natural and spontaneous—has its influential models among the Romantics. But I believe, nonetheless, that we sell our Romantic inheritance short if we imagine that being ourselves can be understood only in these terms. A different, more con-

[17] René Girard, *Mensonge romantique et vérité romanesque* (Paris: Grasset, 1961).
[18] I discuss, more critically, other aspects of Girard's theory in "Une théorie du moi, de son instabilité, et de la liberté d'esprit" [A Theory of the Self, of Its Instability, and of Freedom of Mind], in H. Grivois and J.-P. Dupuy, eds., *Mécanismes mentaux, mécanismes sociaux*, pp. 127–45 (Paris: La Découverte, 1995).

vincing conception can be found in the Romantic writer who most determinedly explored the problem of authenticity—namely, Stendhal.[19]

Stendhal and "le naturel"

Le naturel is Stendhal's term for authenticity and the central motif in all his writings—in his novels, in his psychological and autobiographical works, even in his reflections on literary style. Being natural finds its most emphatic expression in passion. And it has its opposite in *la vanité*, by which we think and feel as others expect us to do—in accord, wrote Stendhal, with "le grand principe du XIXe siècle, 'être comme un autre.'"[20]

We cannot grasp what Stendhal meant by "le naturel," however, if we do not note that, in a second great dichotomy of his thought, he also opposed "la passion" to "l'esprit de l'analyse." As a matter of principle, Stendhal was committed to the practice of acute, disabused psychological analysis. But he was keenly aware of its costs as well. True happiness, particularly as it finds expression in "l'amour-passion," defies description and can only be destroyed by analysis. This view lies at the heart of Stendhal's autobiographical writings. As he wrote in his *Souvenirs d'égotisme* (1832):

[19] A fuller presentation of these remarks about Stendhal can be found in my essay "The Toils of Sincerity," in P. Force, ed., *De la morale à l'économie politique* (Presses de l'Université de Pau, in press).

[20] Stendhal, *Histoire de la peinture en Italie* (1817; reprint, Paris: Le Seuil, 1994), 1:153.

Je craignais de déflorer les moments heureux que j'ai rencontrés en les décrivant, en les anatomisant. Or c'est ce que je ne ferai point, je sauterai le bonheur.[21]

[I was afraid to deflower the happy moments that I have encountered by describing them, by dissecting them. Well, that is not what I will do, I will skip over the happiness.]

The antagonism between analysis and passion epitomizes Stendhal's complex historical position. His intellectual roots lie in the eighteenth century, with philosophes such as Helvétius. But his sensibility, his longing to be "natural," is unmistakably Romantic. To comprehend this opposition between analysis and passion, we must observe that, persuaded though he was by Helvétius that all our actions are motivated by the pursuit of pleasure, Stendhal could not also agree with his principle that "l'homme obéit toujours à son intérêt bien ou mal entendu" [man always acts in accord with his interest, well or poorly understood].[22] Hedonism is one thing, egoism another. The distinctive feature of passionate love, he wrote in *De l'amour*,[23] is its rush after pleasure without any thought of interest. It bestows on its object, in a process Stendhal famously baptized "cristallization," whatever perfections, even contradictory ones, might enhance the pleasure it could enjoy. Authentic pas-

[21] Stendhal, *Souvenirs d'égotisme* (1832; reprint, Paris: Folio, 1983), p. 39.

[22] Claude-Adrien Helvétius, *De l'homme* (1773), 9:6.

[23] Stendhal, *De l'amour* (1822; reprint, Paris: Folio, 1980), p. 27.

sion is a kind of *folie*, driven not by the more or less clever calculation of interest but by the imagination.

For Stendhal, passionate love defies retrospective, systematic analysis for the very reason that it cannot be analyzed when it is being experienced. To reflect on this passion while experiencing it would necessarily be to calculate its advantages and so to destroy it. Reflection, he asserted, is always interested, so passionate and authentic love must itself be unreflective, impulsive.[24] From this it follows that we cannot analyze it in hindsight either. For psychological analysis consists in bringing to light the calculation of interest, perhaps unacknowledged, that propels a given thought or action.

The opposition between reflection and authentic passion is played out in Stendhal's great novel *Le rouge et le noir* (1830). In it the hero, Julien Sorel, moves from a life bedeviled by reflection—his almost every move aimed at his own advancement and modeled on Napoleon's example—to a life consumed by passion, in his love for Mme. de Rênal. Not by accident, the action by which Julien breaks free from the spell of reflection—shooting Mme. de Rênal—seems unmotivated. It is an act of blind rage, an *orage*. The other characters in the novel cannot really explain it. But though Julien's *folie* is inexplicable, it is not absurd. What it expresses is rather clear. Julien himself says about it simply "J'ai été offensé d'une manière atroce" [I

[24] Stendhal, *De l'amour*, pp. 153, 155.

was offended atrociously].[25] Offended by what? Surely by Mme. de Rênal's accusation that his motives in love have been nothing but personal ambition. The accusation is by no means false, at least with regard to his past actions. Far from it! But Julien disproves the charge by *doing* the one thing that will ruin all his plans for advancement, and earn him, in the words of the novel, "la seule distinction qui ne s'achète pas: la condamnation à la mort" [the only distinction that cannot be bought: a death sentence].[26] Shooting Mme. de Rênal expresses therefore the triumph of passion over reflection. But as for *why* Julien does it, *what motives push him* to do it, these questions, in Stendhal's eyes, have no answer. In such a case there can be no motives for action. Julien just does it.

We may be less than persuaded by Stendhal's view that reflection looks necessarily to self-interest. But we should, I think, be able to accept the more general proposition that reflection operates with an eye to the anticipated reactions of others and so always shapes our behavior, to some extent, in accord with social expectations. And with that in mind, we can see the significance of Stendhal's idea that the distinctive thing about being natural is that it is *unreflective*. Thereby he breaks with the two assumptions by which the notion of authenticity has been exposed to the powerful sort of objection that René

[25] Stendhal, *Le Rouge et le Noir* (Paris: Folio, 1972), p. 448.

[26] Stendhal, *Le Rouge et le Noir*, p. 289.

Girard, among others, has presented. Being ourselves is not, in Stendhal's view, being true to an inner self that we already are; it is a quality simply of how we are at the time. Nor does authenticity require that we shake off the extent to which we have been influenced by others. Being essentially unreflective, authenticity entails only that we do not act with an eye to social convention—not that we act unaffected by it. It is a form of individuality that consists less in *what* one believes, feels, or does, than in *how*.

Altogether misconceived, therefore, is the objection that Paul Valéry makes against Stendhal in a famous essay of 1927:

> Croit-on que même l'amour ne soit pas pénétré de choses apprises, qu'il n'y ait pas de la tradition jusque dans les fureurs et les émois et les complications de sentiments et de pensées qu'il peut engendrer?[27]

> [Can one believe that even love is not permeated with things we have learned, that there is not a tradition even in the furors and emotions and complications of sentiment and thought that it can produce?]

Stendhal need not disagree. What we are naturally, in his view, may itself exemplify an all-too-familiar pattern and be shaped

[27] Paul Valéry, "Stendhal," in *Oeuvres* (Paris: Gallimard, 1957), 1:564.

by all sorts of social and cultural forces. After all, the love of passion between Mme. de Rênal and Julien is but the age-old tale of neglected wife and handsome young preceptor. And in *De l'amour*,[28] Dante's story of Paolo and Francesca is repeatedly invoked as a paradigm of passionate love, which it is, though it is at the same time an example of what the effects can be of reading books about passionate love. Stendhal's crucial idea is that being natural is not a matter of being utterly original. It is a point that cynics, of course, will never appreciate. Like Mephistopheles in Goethe's *Faust*,[29] when he dismisses Faust's passion for Gretchen as just one more story of seduction, they can see only the typical and predictable. Faust himself, be it noted, replies to this charge correctly, for he does not deny the conventional features of his love but asserts that it is still true love, since the typicality is not what he feels. What he feels is the overwhelming passion. Such is the human truth that Stendhal saw, too, but that the devil, it seems, is unable to grasp. Being truly ourselves is a matter not of being different from others but of ceasing to guide ourselves by others, taking our bearings from their concerns.

This insight was strikingly illustrated by yet another great Romantic champion of authenticity, Heinrich von Kleist. In the brilliant essay "Über das Marionettentheater" [On Puppet Theater] (1810), Kleist offers several stories to illustrate how

[28] Stendhal, *De l'amour*, pp. 45, 54, 108.
[29] See the debate between Faust and Mephistopheles in *Faust* 1:3051–72.

reflection corrupts what he calls natural grace (*Grazie*) into posturing (*Ziererei*). The most telling of them is a bathing incident. Getting out of the water to dry himself, a young man sees his reflection and notes with pleasure that he has unwittingly assumed the same position as the famous ancient sculpture of the boy pulling a thorn from his foot (*Il Spinario*), which he has recently seen in Paris. But on being asked to repeat the pose, he tries again and again with no success. He can no longer be himself. The problem is not that he lacks originality and fails at being different from others—for not only was he able to do it before, but what he did was identical (and perhaps not by accident) with an illustrious example that he himself knew full well. His failure is instead a failure to be natural. He cannot avoid thinking about his action, seeing it from another's point of view, as he sets out to do what can only be done unthinkingly.

The essentially unreflective character of being ourselves shows what is wrong with a second important charge of incoherence that Valéry brings against Stendhal's ideal of authenticity. Not only is the "natural" self always conventional, but the pursuit of naturalness also involves, he says, "une comédie de sincérité." In drawing the supposed distinction between what it is naturally and what it is conventionally, the reflecting self that draws it cannot be strictly identical with the "natural self" that it thereby isolates. In the project of being authentic,

there is, according to Valéry, an inevitable "division du sujet," which must therefore ruin it.[30]

The trouble with this objection, valid enough in its own terms, is that it imagines authenticity to be a *project*. That is why Valéry assumes that being authentic would have to come about through an effort of reflection, involving the identification with some part of the self. This conception, too, though certainly widespread, is precisely what Stendhal means to reject. He is fascinated by *le naturel* because, being essentially unreflective, it cannot be the goal of a project. To make it one is necessarily self-defeating. Throughout his writings Stendhal displays, to be sure, an acute interest in how people devise and project a certain image of themselves. Think only of Julien's constant and desperate attempt to be Napoleonic in what turn out to be very unpropitious times. But it is not right to suppose—as Jon Elster,[31] for one, has done—that for Stendhal "the supreme goal of this character planning is to become natural," even if it must be, as Elster adds, not as the direct object of pursuit but as "essentially a by-product." Rather, *le naturel* is just the opposite of character planning, and far even from the status of a by-product, precisely because it draws its peculiar

[30] Valéry, "Stendhal," 1:572–73. This criticism of Stendhal and of the idea of the "authentic self" is developed further by Jean-Paul Sartre in *L'Etre et le néant* (Paris: Gallimard, 1943), p. 105. For more details, see my essay "The Toils of Sincerity."

[31] Jon Elster, "Deception and Self-Deception in Stendhal," in Jon Elster, ed., *The Multiple Self*, p. 94 (Cambridge: Cambridge University Press, 1985).

value from the way it can overthrow our plans. The value of character planning is what Stendhal intends to qualify. The contemporary French writer Julien Gracq seems to me to have put his finger on what is crucial about Stendhal's notion of authenticity:

> La seule morale sociale qu'on peut tirer de ses livres est que les buts ne servent à rien, si ce n'est à communiquer à la vie le mouvement au cours duquel le bonheur a la chance de se présenter à la traverse.[32]

> [The only social morality we can draw from his books is that goals are good for nothing except imparting to life the movement in the course of which happiness is lucky enough to bump into us unexpectedly.]

Or as Julien Sorel says in prison to Mme. de Rênal: "Il faut convenir, chère amie, que les passions sont un accident dans la vie, mais cet accident ne se rencontre que chez les âmes supérieures"[33] [You must agree, my love, that passions are an accident in life, but this accident occurs only in superior souls]. In Stendhal's eyes, plans are important most of all because the supreme moments of unexpected happiness, when we think and act naturally, occur by undoing the plans we have formed.

[32] Julien Gracq, *En lisant, en écrivant* [Reading and Writing] (Paris: José Corti, 1982), p. 25.
[33] Stendhal, *Le Rouge et le Noir*, p. 465.

Here we meet the ultimate insight in Stendhal's conception of authenticity, the moral truth that ought to make this part of our Romantic inheritance an essential element in our own self-understanding. It is the recognition of the error in the notion of a *life-plan*. Today the idea is popular, and not only in philosophy, where John Rawls's *Theory of Justice* has made it prominent,[34] that each of us ought to have a "life-plan"—that is, a unified conception, at least in broad strokes, of our overall purposes and the ways to achieve them, so that we may thus, as it is said, "take charge of our lives." But such a view embodies a deep mistake. Life is not properly the object of a plan. Plans of more modest scope can, of course, be valuable. But there is value, too, and value of the greatest significance, in how life can upset them. Clearly, just being ourselves had better not take up all that we are. But neither ought we suppose that a plan can assign this phenomenon its proper place in life. The importance of the Romantic theme of authenticity is that it disabuses us of the idea that life is necessarily better the more we think about it.

In this chapter I have focused on the two leading Romantic contributions to our modern sense of individuality—the ideas of irony and authenticity. Understanding these notions better, clearing away the misconceptions that beleaguer them, increases our knowledge of Romanticism and of ourselves.

[34] John Rawls, *A Theory of Justice* (Cambridge, Mass.: Harvard University Press, 1971), pp. 407–16.

This dual purpose, historical and philosophical, has been my guide throughout this book.

But it will surely not have escaped notice how heterogeneous and fraught with tensions is the Romantic image of ourselves at which I have arrived. The imagination may be the common denominator of the three other themes I have examined—*belonging*, *irony*, and *authenticity*. But in them it takes very disparate forms. The two modes of individuality constituted by irony and authenticity are as different as they can be. The one is inherently reflective, the other is essentially unreflective. It is altogether obscure how—that is, on the basis of what overarching considerations—the two can be combined in a systematic way. Indeed, the very import of the value of authenticity is that such a way of thinking, involving the construction of a life-plan that would give each good thing its proper due, is fundamentally flawed.

An added complication, of course, is that authenticity stands in considerable tension with the no less valuable Romantic theme of belonging. Here, too, the chances of an accommodating synthesis are slim. Belonging, as I proposed we understand it, embodies a new conception of reason, which the Romantics introduced and which we are still struggling to make our own. The urge to "be ourselves," however, does not arise from our commitment to being rational (even as reconceived), and we should not expect these two aspirations constantly to converge. Of course, the points at which acting nat-

urally departs from reason can always be pronounced "irrational." But we ought not suppose that there is anything more to be said, and that in particular such unreasonable behavior is unfortunate or that irrational individuality must be bad. It is surely an illusion to think that things always turn out better when people act reasonably.

With all this in mind, therefore, I will not seek to bring this book to any tidy conclusion. I cannot say that I am disappointed by such an outcome. To be sure, complications should not be welcomed for their own sake. But neither should they be ignored or regretted, just because they prove difficult. The important task is always to see clearly what lies before us. Our Romantic legacy is too complex and diverse a thing to form a harmonious whole. But our lives are the richer for it.

INDEX

Edwards Brothers Inc.
Ann Arbor MI. USA
March 25, 2011